CHINESE ANIMAL PAINTING
MADE EASY

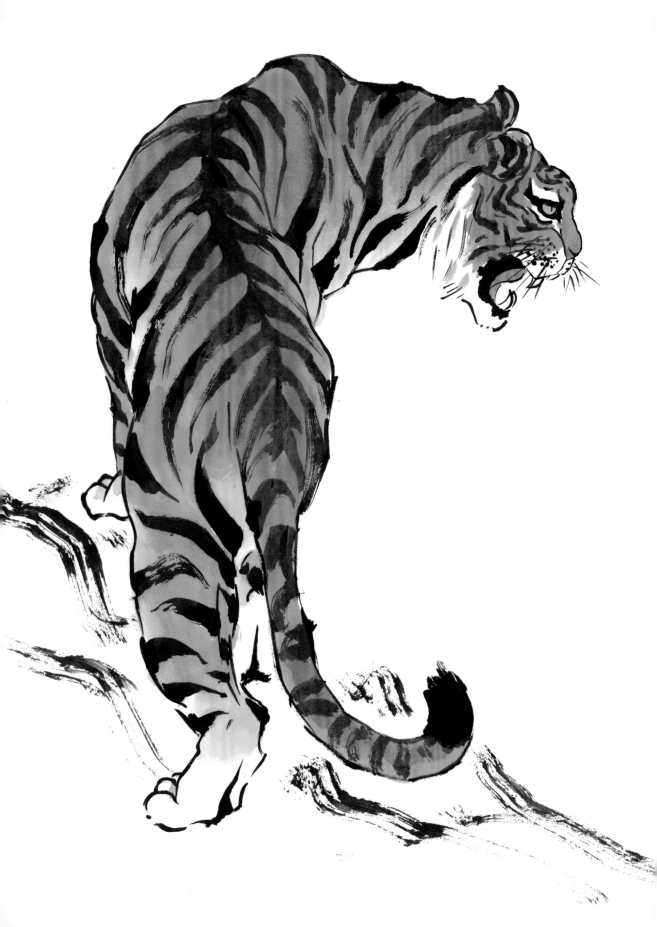

CHINESE ANIMAL PAINTING MADE EASY

Rebecca Yue

WATSON-GUPTILL PUBLICATIONS / NEW YORK

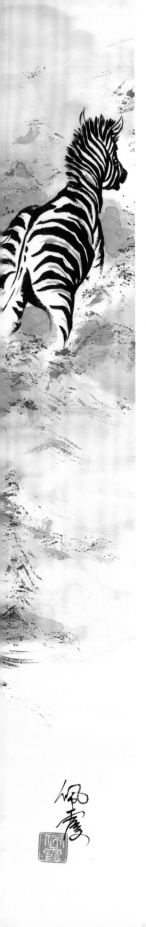

First published in the United States in 2009 by
Watson-Guptill Publications,
an imprint of the Crown Publishing Group,
a division of Random House, Inc., New York

www.crownpublishing.com
www.watsonguptill.com

Copyright © Batsford 2009
Text and illustrations © Rebecca Yue 2009

ISBN 978-0-8230-9797-5

Library of Congress Control Number: 2009920541

17 16 15 14 13 12 11 10 09
10 9 8 7 6 5 4 3 2 1

Reproduction by Mission Productions Ltd, Hong Kong
Printed and bound by NPE Print Communications Pte Ltd, Singapore

ACKNOWLEDGMENTS

I started writing this book at the beginning of 2007. However, this was to prove a year of mixed fortunes. The high note, of course, was the publication of my fourth book on Chinese art, *Chinese Landscapes Made Easy*, which was subsequently shortlisted for 2007 Practical Art Instruction Book of the Year. Shortly after that it was confirmed that I had cancer and so began the long and tough fight for my life. Let me take this opportunity to offer heartfelt thanks to my family, my pupils, and all my friends around the world, who supported me through this difficult time.

There were good days and there were bad days. Continuing to work on this book enabled me to focus amid a sea of mixed emotions. Now, late in 2008, I have finished writing it. Also, my doctor has given me the all clear, so this book has become a celebration of a new chapter in my life.

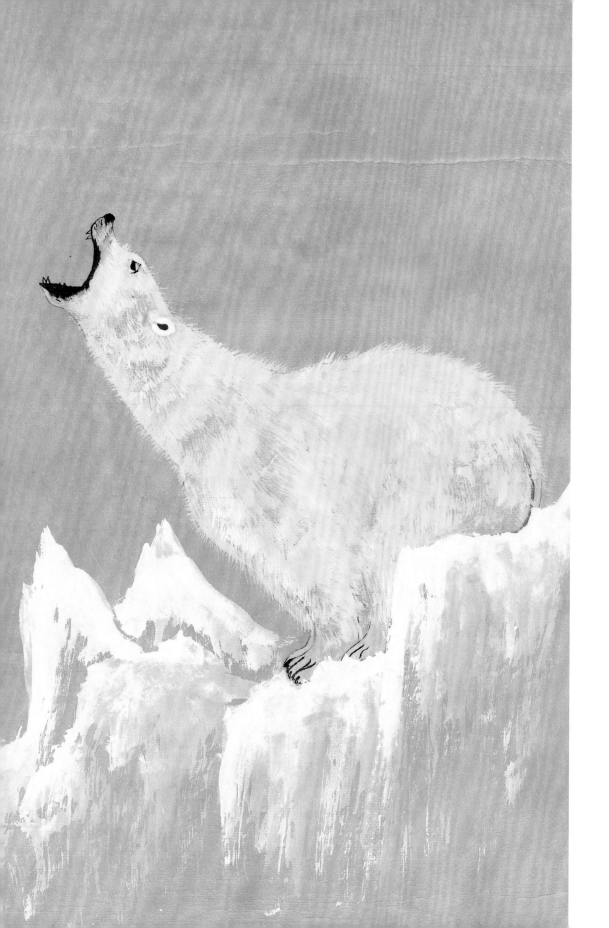

CONTENTS

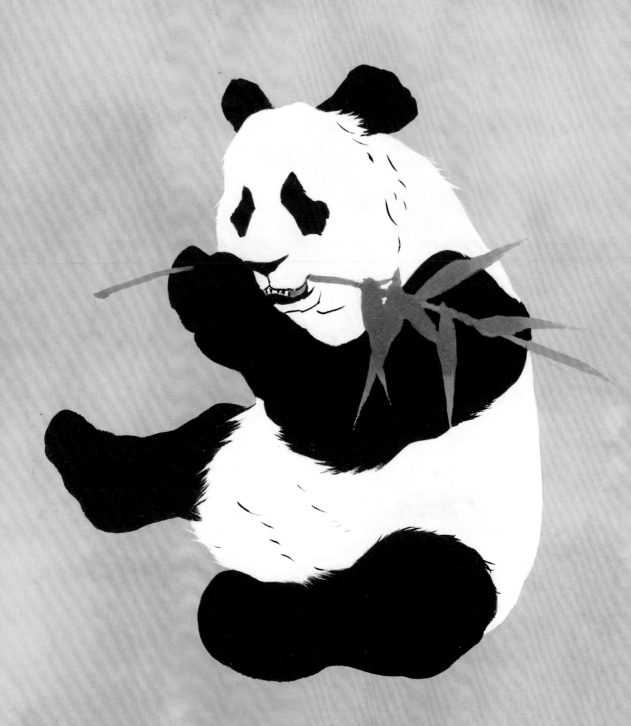

INTRODUCTION

As with all subjects found in Chinese brush painting, you can paint animals either with a detailed and elaborate outline style or with the expressive non-outline approach. In the ancient period, almost all paintings of animals were executed with the outline technique. This style emphasizes the details. Figures are drawn carefully: every detail is depicted in the outlines, and layers of colors are applied one after another to create tones and depth. Artworks of this style are usually painted on Xuan paper or silk, sized with alum and gum to make them non-absorbent so that colors can be spread in a controlled way. The outline style remains a popular technique among artists for painting animals.

The Chinese non-outline approach to painting animals became popular around a hundred years ago, so it is relatively modern compared with the outline style. However, the non-outline style has developed so rapidly over the last hundred years that it has come to dominate animal painting in modern times. "Non-outline" does not mean that you cannot use lines in a painting. However, lines are used in a more flexible, expressive way than in the outline style. Another distinctive characteristic of the non-outline style is that Chinese brushes are maneuvered to create brushstrokes. These brushstrokes form shapes, creating movements as well as tones.

Animals and people are usually subjects that come toward the end of an apprenticeship in Chinese brush painting. Many artists may never embark on this stage, deciding instead to specialize in other subjects, such as flowers and birds or landscapes. There are two types of animal painter. The first are those who follow a general training, briefly studying every subject featured in brush paintings. At the end of their training, if they decide to specialize in painting animals, each of them will seek to enroll with a master who has specialized in that subject. However, the majority of animal artists have already become accomplished artists in other categories of Chinese brush painting before they turn their full attention to painting animals. Each of the latter group will already have succeeded in developing his or her unique style, as well as polished techniques. When they apply these qualities to animal painting, they create a wide range of styles, combined with highly advanced techniques. Also, because they are accomplished artists, they are not afraid to stretch the brush to produce amazing new effects. As a consequence, it can be confusing and daunting for newcomers to Chinese brush painting who want to learn to paint animals and take these masters as their models.

Perhaps if we can understand how a master approaches painting an animal, we may find a way to follow their example. Actually, there is no real mystery here. We usually start with all the basic techniques at our disposal. We then experiment with all of them, combining, stretching, and varying them, until we finally discover a form that we feel perfectly expresses our concept of the subject. Each artist has his or her own conception of an animal. The character, the movement, the location, and the relationship between each artist and animal are all different. So the outcome is significantly different from one

artist to another. It is also interesting to know that while some masters prefer to paint all their animals using one technique, many others choose to mix many techniques in their work.

Bearing this in mind, I have decided to guide my readers to think like accomplished artists. As with many areas of artistic endeavour, the key is to master the basic techniques. Throughout the book, before painting each animal, I will demonstrate how to combine and vary basic techniques to form complex strokes with which to depict particular animals. And, in the course of learning, you will also embrace many of the more popular Chinese styles of painting animals.

The learning process begins with knowing the correct materials and equipment. Readers who have used my other books to learn aspects of Chinese brush painting will be familiar with the majority of items I have chosen to use here, but I will list all of them again. In addition, I am introducing two new types of brush that are essential for effective animal painting, as explained here.

The first of these is a large brush. This is a very convenient tool for painting large shapes, such as the body of an animal, but you have to work on the press-and-lift technique a bit more if you are to create a shape successfully. Bear in mind that the original artworks in this book are much larger. We have had to size them down to fit into this book. So when you practice using the examples in this book, you can use the large brushes and work on a grand scale.

I also introduce you to a slender brush for painting the more delicate features of animals, such as the faces and the feet. People are usually attracted primarily to the expressive broad brushstrokes that characterize Chinese brush painting. Many might imagine that the non-outline way of painting animals would only use broad, expressive brushstrokes of this type. Contrary to what these people may think, detailed and delicate brushstrokes are equally attractive and just as essential to painting animals. Experienced artists always use a balance of delicate as well as broad brushstrokes to create a composition with many contrasts, showing the whole character of the animal. In fact, this principle applies to all subjects of brush painting. Detailed, delicate features will enhance an artwork made up of broad, expressive brushstrokes because they highlight the beauty of the latter. The illustrations in this book will very much reflect this principle, so this slender brush will prove a useful and essential tool.

I am keeping the chapter of basic techniques very simple. I will therefore not go into too many variations and combinations. The whole aim is to let you concentrate on getting the simple forms of the basic techniques right at the very beginning, so that when we come to use them later to develop the more complex forms, you will not feel hesitant. The section on "Maneuvering Chinese Brushes" contains important information, particularly about using Chinese brushes for painting animals. I will give you hints on using different brush sizes, especially the very large one and the very slender one. Then

there is the essential instruction on loading a brush so that you have the right amount of moisture. Painting animals requires a delicate balance of moisture in the brush. Moisture causes colors to run, so too much moisture often leads to bleeding beyond the intended outline, resulting in a clumsy effect.

The wrist movement, elbow movement and press-and-lift techniques are fundamental to using a Chinese brush effectively. The brush is used on its side more with animal painting than with any other subject found in Chinese brush painting because this creates broader brushstrokes. There are several ways of using the brush on its side, as I will explain. Dry brushwork and wet brushwork are also essential skills, and when these two are used in a controlled way, they lead to many advanced techniques, such as toning and broken brushstrokes.

After the initial hard work and practice, we will come down to the business of painting animals. The chapter about painting animals has been organized according to various styles. I have chosen the more popular and practical styles for your learning process, starting with simple sketches using an informal application of colors. It is important to be accurate about shapes and proportions in animal painting. The sketches have been designed to help you work on this aspect and they will hopefully prepare you for learning the other styles that lie ahead. Following on will be styles using techniques of basic brushstrokes, applying tones and broken brushstrokes—in this order. Each succeeding style is more advanced than the one before and along with each there are illustrations suited to that technique. I may therefore repeat an animal, illustrating it in more than one style. My purpose here is to show you that each animal can be painted in many different ways. Overall, I aim to use the minimum number of brushstrokes needed to bring out the true sense—the shape, the character and the movement—of an animal. It is a challenge, but this is the beautiful essence of non-outline Chinese brush painting. The chapter concludes with a session on painting animals with patterns, allowing you freely to apply all or any of the styles you have acquired.

Some of the instructions in this book may appear to be overly technical. However, bear in mind that techniques developed by accomplished masters can be complicated. In order to make sure that you understand how to achieve them, it's necessary to lay down systematic and detailed instructions for each technique, at the same time showing you how the brush works and how your hand works. You can then refer to these instructions anytime you feel the need.

In working through this book, you will find it a bonus if you have experience in painting other types of subjects because you will be able to apply your basic techniques more fluently. However, I have no doubt that beginners will eventually catch up if they practice the skills and techniques suggested in this book. If, on the other hand, you are an artist who has already started to paint animals, this book has been designed to help you by thoroughly explaining the various approaches. You can paint a single animal in many different ways, so there are always new avenues for advanced Chinese brush painters to

consider. Hopefully, this book will provide stepping stones that will help you to understand which skills you have already mastered, and discover what else is available for you to further explore.

The Gallery section contains an exhibition of animal painting, combined with flower and landscape painting techniques. You will see how other subjects can enhance your animal paintings. All the artworks in this chapter are the result of simple, and at times almost abstract brushstrokes, through which I hope to give you further insight into the expressive world of the Chinese brush. The only way to reach the stage at which you will be able to create similar works with your own unique insights and style is to be fluent in using the basic techniques. So it is time to make a start with the basics, repeatedly practicing the many approaches and experimenting with ideas and techniques.

Animal painting requires you to be adventurous, to be inventive, to be daring, and not to be afraid to experiment. Use your brush freely. Always aim to expand what you can achieve. Stretch the brush to attempt what you think is impossible. I hope I have given you a good beginning. It will be your turn to work on what you have taken here and go on expanding it. I hope that you will try painting animals other than those illustrated in this book, using the techniques you learn from here. Someday, I also hope that you will develop your own style of animal painting.

Painting animals with Chinese brushes can become a virtually endless voyage of discovery and experiment. For example, one could easily write a book about each animal that is illustrated here. It is a challenge to us that we should not stop here, but instead go forward to bring this art form to a higher level.

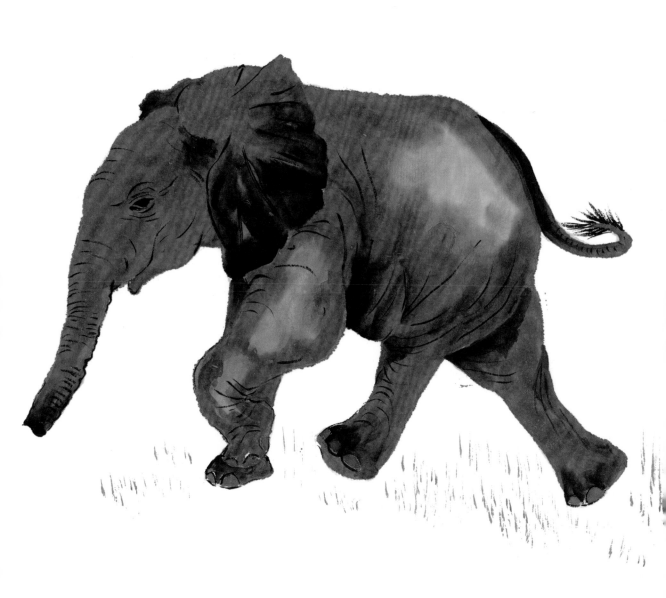

1 MATERIALS AND EQUIPMENT

CHINESE BRUSHES

A traditional Chinese brush has a bamboo handle and a brush tip made of animal hair. Carved wood, animal horns and bones, ceramic or cloisonné, and even jade are also used for making handles, and in the last few years, an increasing number of manufacturers have been replacing the bamboo brush handles with wood or plastic.

Usually brushes are classified as "soft hair" (軟毫) or "tough hair" (硬毫) according to the type of hair used for making the brush tips. Soft-hair brushes are usually white and tough-hair brushes are dyed brown or black. In animal painting, brushes used for creating hair and fur are used in a very rough way. We need tough brushes to withstand the rough treatment. We also need brushes for general painting: applying colors, creating tones, and adding accompaniments, such as trees, rocks, flowers, and sky. However, rough painting wears out brushes faster than usual. For this reason, it is not advisable to use the same brush for rough brushwork and for general painting. I usually keep a few brushes exclusively for rough painting and separate them from the rest of my brushes. When those used for rough painting are worn out, replace them with those from the general painting group and buy new ones to replace those used for general painting.

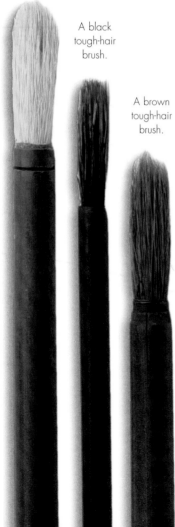

A white soft-hair brush.

A black tough-hair brush.

A brown tough-hair brush.

SOFT-HAIR BRUSHES

Soft-hair brushes are made from the hairs of goats, chickens, or lambs. Goat is the finest of all soft hairs and is therefore the most popular for making brushes. White-hair brushes are very soft and can take in a lot of moisture. For non-outline painting, however, I prefer the flexibility of the brown-hair and black-hair brushes. I have only used the white-hair brushes for creating washes in this book. The following two types are good for this purpose.

A **Goat-hair Ti brush** (羊毫提筆) is a big brush. Ti brushes can be made of any type of hair. Soft-hair Ti brushes are good for creating washes. They can also be used for general painting, if you choose. There is a wide range of Goat-hair Ti brushes and they are generally not very expensive, so get the biggest one you can afford.

A **Hake brush** (底紋筆) is a wide, flat brush. The hair may be black or white. The white ones are made of goat hair and are much cheaper than the black ones. There are five widths available in the white-hair type: 1 in (2.5

cm), 1½ in (3.8 cm), 2 in (5 cm), 2½ in (6.4 cm) and 3 in (7.6 cm). Hake brushes wider than 3 in (7.6 cm) are usually made for mounting in the traditional way. For creating washes, a brush between 2 and 3 in (5 and 7.6 cm) wide would be adequate. I keep both a 2 in (5 cm) and a 3 in (7.6 cm) Hake brush. It is more convenient to have two Hake brushes when you are doing a multi-color wash, using one brush to hold one color and the other to hold the second color. The 2 in (5 cm) Hake brush can also be useful for general painting. Avoid Hake brushes with metal necks because they will rust after getting wet a few times.

There is an alternative to the Hake brush, called a **Pai brush** (排筆). "Pai" means lining up side by side. Pai brushes are made up of from two to six single brushes that are linked together side by side. They usually have goat-hair brush tips. These are cheaper, but are not as well made as the Hake brushes.

TOUGH-HAIR BRUSHES

BROWN-HAIR BRUSHES

The brown tough-hair brushes are made from the hairs of foxes, wolves, rabbits, camels, and many other animals. Chinese brush manufacturers are continually experimenting with new brown hairs and today we have a much greater variety of brown-hair brushes than our ancient masters. Brown-hair brushes are more flexible than the soft-hair type. When the brush tip of a good-quality brown-hair brush is pressed, it fans out easily, creating broad brushstrokes. When the brush is lifted, it always returns to the upright pointed position. Different degrees of pressure on the brush tip are used to make the brush fan out to different widths. This quality makes these brushes preferable for general painting. There is a wider range of brown-hair brushes available than of those made with white or black hair. The following four differently sized brushes are my basic choice for general painting, and these will enable you to create a wide range of brushstrokes.

Small Orchid and Bamboo brush (小 蘭 竹). This is the largest of the four brown-hair brushes that I recommend here. As the name suggests, it is made especially for painting bamboos and orchids. It is a popular brush for painting flowers, but we can use it for large brushwork in animal painting and for general painting. It is especially useful for applying colors over a large area. The Orchid and Bamboo brush is very popular, so every manufacturer makes its own brand. This results in a wide range of qualities, which makes choosing a good one very confusing. The only advice I can give you is that if you are not happy with the one you have, buy one made by a different manufacturer when yours has worn out.

Size 3 Leopard and Wolf brush (三号 豹 狼 毫). This is one of the best medium-sized brushes due to the quality of hair used to make the brush tip, which is smaller and shorter than that of the Small Orchid and Bamboo brush. It is a good brush for painting medium-sized brushstrokes. There are usually three sizes of Leopard and Wolf brushes

available: size 1, size 2 and size 3 (the smallest size). You may also find an extra-large size 1, extra-large size 2 and extra-large size 3, but only in quality art shops.

Red Bean brush (紅豆). The hairs of this brush are trimmed to form a slender point at the brush tip, making this a very useful brush for sketching, small-scale work, and adding details. The tip is dyed black and red. In ancient times, Red Bean brushes were dyed in red bean juice, hence the name.

Size 1 Wolf-hair brush for Painting (一号狼毫国画笔). This brush has a very thin brush tip, which is carefully trimmed. It is useful for final touches, such as the iris of an animal's eye or its teeth, but because it can hold only a small amount of moisture, it is not advisable to use this brush for sketching. There are many versions of these tiny brushes. The one I have chosen has the tip tugged through two tiny wooden rings. This gives extra security, keeping the little bundle of hairs in place. When you search for this brush, look for those with the wooden rings (see the photograph below).

A LIST OF ESSENTIAL BRUSHES
Below is a list of all the brushes I recommend for learning to paint animals, as described in this book.

1. Size 1 Wolf-hair brush.
2. Red Bean brush.
3. Size 3 Leopard and Wolf brush.
4. Small Landscape brush.
5. Large Landscape brush.
6. Small Orchid and Bamboo brush.
7. Goat-hair Hake brush, at least 2 in (5 cm) wide.
8. Goat-hair Ti brush.
9. Small Mountain and Horse brush.

Optional (shown on page 19)
• Extra-large Mountain and Horse brush *or*
• Large Bear-hair brush *or*
• Wolf-hair Dou brush.

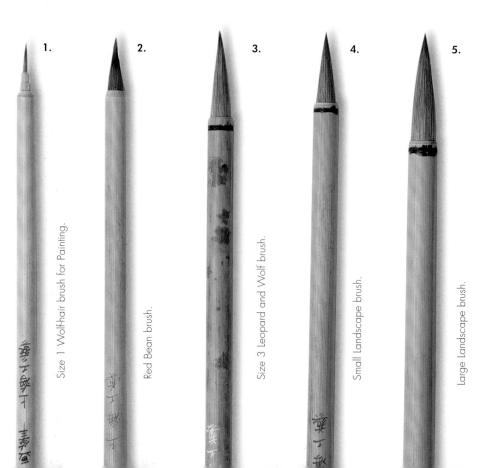

1.

2.

3.

4.

5.

Size 1 Wolf-hair brush for Painting.

Red Bean brush.

Size 3 Leopard and Wolf brush.

Small Landscape brush.

Large Landscape brush.

A popular technique for painting animal hair is to use broken brushstrokes. To create a broken brushstroke, the brush tip of a dry brush is pressed before or after the loading of colors until the hairs separate. Either way, this is very damaging to the brush hairs, and even a tough black-hair brush will wear out faster than usual. So we are looking for tough brushes in the brown-hair and black-hair categories. In general painting, we can create different sizes of brushwork by varying the angle at which the brush tip touches the paper. However, in creating broken brushwork, the brush is always held vertically, which means that you can only paint different sizes of broken brushwork by using different sizes of brush. I would suggest that you have two brushes of different sizes from the brown-hair range and one from the black-hair range. For the paintings in this book, I used two brown-hair Landscape brushes and a small black-hair Mountain and Horse brush.

Landscape brushes (山 水 筆). These are made for rough brushwork. There are three sizes of this type of brush: large, medium, and small, all of which are reasonably inexpensive. A small Landscape brush and a large Landscape brush will be useful to start with. These

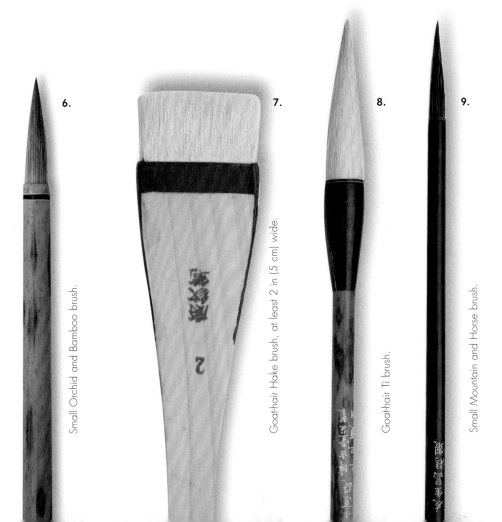

6. 7. 8. 9.

Small Orchid and Bamboo brush.

Goat-hair Hake brush, at least 2 in (5 cm) wide.

Goat-hair Ti brush.

Small Mountain and Horse brush.

two brushes will be used to paint small and medium broken brushwork. You will need a larger brush to paint larger broken brushwork. For this, I choose a black-hair brush—the small-sized Mountain and Horse brush (see below). You could choose two extra-small Mountain and Horse brushes instead of the Landscape brushes, but the former are expensive. Landscape brushes are much cheaper and this makes frequent replacement more affordable.

We also need a brush to paint the delicate features of animals, such as the nose, eyes, and mouth. The size 1 Wolf-hair brush for Painting can do the job, but the tip of this brush is very small, so the brush can only hold a very small amount of ink, which means that you constantly have to keep dipping into your color to refill, even when you are only painting an eye. Ideally, you need a very slender brush that can create thin lines and small, delicate brushmarks. At the same time, it needs to carry more color so that it can go a longer way. For this purpose, I recommend that you select an Outline brush.

Outline brush (勾線筆). There are many brushes used for outline painting. This particular example is one of the most popular. If you can't find the one I suggest here, choose one that has a very slender brush tip but at least double the length as well as the width of the size 1 Wolf-hair brush for Painting. You will probably find one from the range of brushes for outline painting.

BLACK-HAIR BRUSHES

Black-hair brushes are made of even firmer hair than the brown-hair type. The hairs are those of the horse, hog, raccoon, and other animals with tougher hairs. These brushes carry even less moisture than the brown-hair ones. Experienced artists make use of this quality to create expressive rough and dry brushwork in animal painting. Brushes in this category are more expensive because hairs for making brushes of this type have to be of very high quality; if they are too old or hard, the brush will not hold moisture. They can't be too soft either, or they will not create the special dry and rough effects.

A very popular black-hair brush is the **Mountain and Horse brush** (山馬筆). The best mountain and horse brushes are made entirely of horsehair and are dyed black. Cheaper versions of this brush are made either with a mixture of brown hair and black hair or of brown hair dyed black. I personally prefer those made entirely of horsehair. There are six sizes of these horsehair brushes: large, medium, small, extra-small size 1, extra small size 2, and extra small size 3. For the exercises in this book, you only require the small size. Again, I remind you that we use brushes very roughly in animal painting. Even the black-hair brushes wear out faster than usual.

LARGE BRUSHES

The illustrations in this book have been scaled down. Many Chinese artists paint animals in very large sizes. The bigger they are, the more expressive the brushwork, but of course you require very large brushes. I am going to recommend a few of these to you in case you would like to try painting larger artworks.

In practice, I have used two large brushes for some of the illustrations and I will explain how they are used. However, I have also provided you with alternative instructions in case you do not wish to purchase these brushes.

Extra-large Mountain and Horse brush (特 大 山 馬筆). There are actually three sizes in this group, but some manufacturers make only one size, which they simply call an extra-large Mountain and Horse brush. Unfortunately, the quality of extra-large Mountain and Horse brushes varies a lot, depending on the manufacturer. Since this brush is usually very expensive, it is safer to acquire it through a reputable Chinese art material supplier.

Bear-hair brush (熊 毫 書畫). This is a relatively new brush. Bear hair is tougher than wolf hair, but softer than horsehair. Manufacturers usually dye the hairs black and include them in the black-hair category. There are a few versions of the Bear-hair brush now available. This particular brush comes in three sizes and I have used the large size for painting some of the illustrations in this book. One warning about this brush: it can soak up a lot of moisture, so before you use it be sure to prepare a larger quantity than usual of ink or colors. Also, if the brush is wet, try to squeeze out as much moisture as possible before loading it with color, or the extra moisture in the brush will dilute the color and soften your intended tone.

Wolf-hair Dou brush (狼 毫 斗筆). Dou brushes are similar to Ti brushes. Dou brushes can vary, both in the size of the brush itself and in the length of the brush tip. There are many types of Wolf-hair Dou brushes. Look for one that has a long brush tip. Get a large one that suits your wallet.

A large Bear-hair brush.

A Wolf-hair Dou brush.

An extra-large Mountain and Horse brush.

"OPENING" A CHINESE BRUSH

The tip of a new Chinese brush is held together neatly with gum. This is only for presentation. The tip is also usually protected with a bamboo or plastic cover when it is new. Before using a Chinese brush for painting, the brush needs to be "opened". "Opening" a brush means removing the gum and loosening the hair. Begin this process by soaking the brush tip in cold water. Avoid using hot or warm water—people sometimes use warm water to hasten the process of removing gum, but in my opinion this does not save time. Using warm or hot water for the opening process generally has two effects on a brush: the hot water shrinks the hair, making it tougher and losing the shape it was trimmed into; in addition, the brush tip is secured in the handle with a little bit of glue and warm or hot water will loosen this, causing the tip to fall prematurely. Prolonged and unnecessary soaking of the brush in water will also do this, which is why you should never soak brushes in water when not in use.

Soak your new brush in a jar with sufficient clean cold water to cover the brush tip. For the majority of brushes, twenty minutes will be sufficient to loosen the gum on the brush tips. A Ti brush or Dou brush needs a longer soaking time — about half an hour. After soaking the new brush in water, press the brush tip gently with your fingers. If the hairs are soft and separate, the brush is properly "opened". If the tip is still hard and will not separate, do not force it by bending. Return it to the water to soak for a longer time. When the brush is fully opened, rinse it thoroughly in clean water to remove all the gum. Dry it between tissues or with a soft towel. The brush is now ready to serve you.

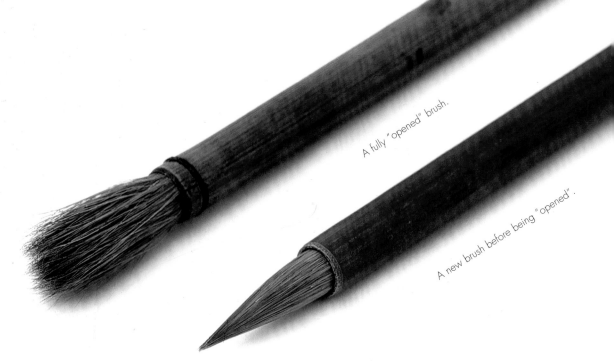

A fully "opened" brush.

A new brush before being "opened".

CARING FOR CHINESE BRUSHES

There are a few things you can do to keep your brushes in good condition and help them to last longer.

- Do not put your opened brush back into its bamboo or plastic cover. When a brush is opened, the brush tip will be too big for the cover and squeezing it back in will damage or distort the hairs.

- Do not store wet or damp brushes in airtight containers, such as plastic bags. Chinese brushes are made of natural materials and they can rot in damp conditions. Always dry them completely before storing them. When the brushes are not in use, you can store them in opened jars, with the tips of the brushes pointing up. Brushes that come with loops of cord at the top can be hung on specially made brush hangers. You will find these hangers for sale in the shops where you get your Chinese brushes. It's also easy to make one.

- If you need to carry the brushes with you on painting trips or to and from classes, the best way is to wrap them in specially made brush mats. These are made up of thin bamboo sticks bound together and have gaps to allow brushes to breathe and dry. Unfortunately, if you are not careful, your precious brushes will fall out from the open ends and get lost. However, I have a trick for keeping the brushes securely in place within the mat: Cut a length of dressmaking elastic, equal to the width of the mat, and thread it through the gaps of the mat, securing the two ends of the elastic with stitches. The loops formed by the elastic are perfect for holding the brushes.

Chinese brush mats are available from Chinese artists' suppliers. I have adapted this one to make sure the brushes don't fall out by threading it with dressmakers' elastic. The elastic is secured at the ends with a few stitches.

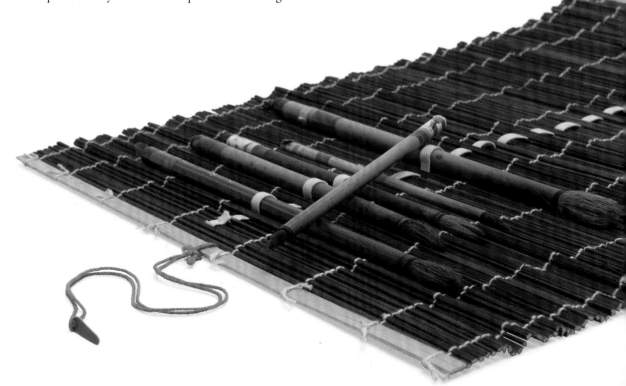

Do not use a quality brush for mixing colors. Either buy a cheap watercolor brush for this purpose or use an old Chinese brush.

After each painting session, always clean your brushes of as much ink and color as possible. Sometimes you will find that it is difficult to remove colors and ink stuck around the neck of the brush. When this happens, soak the brush in a jar of clean water and let the colors diffuse into the water. This will help to dissolve most of the color. Wipe off excess moisture before storing brushes away. Do not clean any of your brushes with soap or dishwashing liquid. Dishwashing liquid and soap, once attached to the hair, are difficult to remove and can sometimes form a barrier, which will interfere when picking up colors with the brush.

The brush tip of a quality brown-hair or black-hair brush always returns to a point when wet. When this fails to happen, the brush has passed its serving time and you should consider replacing it with a new one. However, do not discard the old brushes, as they can be used for mixing colors. The big ones are also perfect for rough and dry brushwork, as used to suggest fur (see page 74).

PAPER

We use **Xuan paper** for Chinese animal painting. This paper is made from a mixture of tree barks, plants, bamboo, cotton, and other materials. The proportions of each material differ by manufacturer and each company guards its secret formula for making its brand of Xuan paper. Some of these formulas have been passed on from ancient times and each one has a name. This is usually printed at one corner of a sheet or across the side of a pack of 50 or 100 sheets. Xuan papers are usually available in loose sheets measuring approximately 26 x 52 in (66 x 132 cm), though some varieties are bigger. There are two types of Xuan paper: the absorbent unsized Xuan and the alum-sized Xuan. In non-outline animal painting, we use the absorbent type.

Chinese absorbent Xuan paper is available in different thickness. We call the thinnest "one sheet;" the next thickness is "two sheet;" then comes "three sheet," while the thickest is "four sheet."

The "one-sheet" papers are relatively cheaper than the others, so it is economical to use these for learning and for practice. The "two-sheet" ones are more suitable for serious painting. Chinese artists prefer the "three-sheet" and "four-sheet" Xuan paper for animal painting, but these papers are seldom available outside China. Even in Asia, only shops specializing in quality Chinese painting materials stock the "three-sheet" and "four-sheet" papers. In many cases, "four-sheet" Xuan papers seldom make the trip from the factory to the shop because artists sweep them all up as soon as they are made. In places where "four-sheet" absorbent Xuan paper is not available, some artists will go as far as to paste

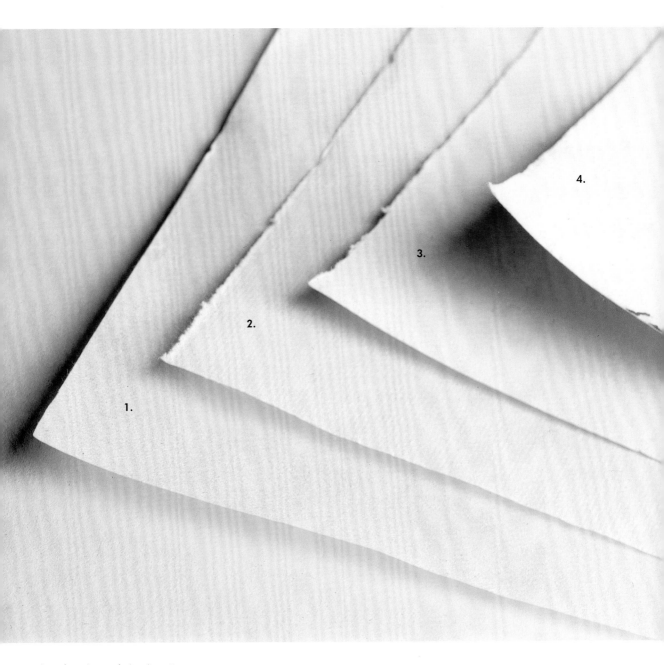

These four sheets of absorbent Xuan paper
are "one sheet," "two sheet," "three sheet,"
and "four sheet," but you can't really tell the
difference until you feel the paper.

two "two-sheet" papers together to create a "four-sheet" one. The Xuan paper available in the U.S. is usually of the "one-sheet" thickness, but art shops that stock Chinese painting materials can always order the "two-sheet" thickness for you if you want a sufficiently large quantity. Absorbent Xuan paper is usually sold as loose sheets or in large packs. Sometimes the papers can be cut in half lengthwise and sold as rolls of twelve or fifteen half sheets.

Besides the Chinese, the Japanese and the Koreans also make Xuan Paper. There is one made according to a Japanese formula called "**Moon Palace**" (月宮殿). This Xuan paper is of "two-sheet" thickness in continuous rolls, usually of about 50 feet (15 meters) long for each roll. There are three widths available: 15 in (38 cm) wide, 18 in (45.5 cm) wide and 24 in (61 cm) wide. The advantage of this paper is that it is widely available in art shops. It has a smooth side and a rough side. I usually advise my pupils to use the smooth side for painting, though some artists prefer the rough side for rough and dry brushwork. Moon Palace is a good-quality Xuan paper. If you are happy and comfortable with it, there is no reason why you can't continue to use it. However, it's worth pointing out that Moon Palace is not everyone's favorite, as many people find it difficult to control the absorbency of this paper.

A roll of Moon Palace, 15 in (38 cm) wide.

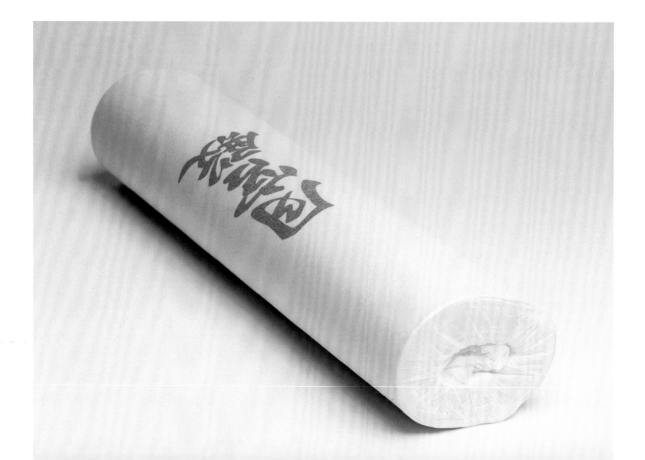

You can cut a piece of absorbent Xuan paper, whether it comes in a loose sheet or in a continuous roll, with a wet brush. Draw a line with a wet brush where you want to make the cut and then pull the paper apart. The two sides of paper will separate easily.

Other absorbent Xuan papers come dyed in a variety of colors. The most popular ones for animal painting are the ones tinted with blue or green. You can also make your own tinted paper with color washes (see page 172). You can also create paper with multi-tone or multi-color washes. This is especially useful, as Xuan papers tinted with more than one color or tone of a color are seldom available in the shops.

Green and blue absorbent Xuan paper.

Flower Xuan paper and smooth-textured Mulberry paper.

There are other Xuan papers that have extra texture in them, such as flecks of gold paper mixed in the pulp when the papers are made. There are red, pink, beige and white gold-speckled papers. These are popular for paintings for celebrations, such as Chinese New Year, when people like to paint the animal of that year on the red gold-speckled paper, or to celebrate a person's birthday by painting the animal of the year the person was born. There is also a paper with flowers and leaves embedded in it. This has an atmosphere of nature and gives a very pleasant background to animal painting. However, the textured papers are not a favorite among animal artists because the flecks can sometimes distract people from the delicately painted features of the animals.

Mulberry paper is another good-quality absorbent paper for painting. This paper is slower to absorb moisture than the usual absorbent Xuan paper, allowing the brushwork to be more controlled. The mulberry paper made for Chinese painting is not the same as that made for craftwork: the papers made for Chinese painting have a tighter texture and are available in two types. One type is coarse, with beautiful patterns created by the mulberry fibers. Washes painted on this paper have a very dramatic effect. The other type has a smooth texture. Mulberry paper can be white, light beige, or dark beige in color. Animal painters prefer the smooth type because too great a density of fibers can distract the viewer from the detailed features of animals, especially the facial features.

I personally prefer the "three-sheet" and "four-sheet" thickness of Xuan paper for animal artworks. However, since most readers will not be able to get hold of these, I have used loose sheets of "two-sheet" absorbent Xuan paper for all the illustrations in this book. If absorbent Xuan paper of "one-sheet" thickness is the only type available to you, it is perfectly fine to use it, but try not to load your brush with too much moisture during painting. (I will give you tips about loading the brush with ink or colors as much as possible throughout the book.) It is also advisable to change your underlining sheets more often before they get too wet.

White mulberry paper with texture and gold-speckled paper in beige.

INK

Non-outline Chinese animal painting is very ink-dominated, so I will generally be using ink in this book.

It is traditional to make ink by grinding an ink stick on an ink stone. However, liquid ink has been around for quite a long time and many artists now use it for painting. There is always a difference of opinion over whether we should only use ink made by an ink stick or whether it is acceptable to use liquid ink. Many argue that ink made by grinding is thicker and of better quality, claiming that one can achieve different grades and tones only by using ink made in this way. I personally don't agree with this. After all, both ink sticks and liquid ink are made from the same ingredients. I feel it's a matter of habit and knowing how to use your ink. There are many types of good-quality liquid ink that are very thick and very dark. I am convinced that either type of ink will serve the purpose and you should use whichever you prefer. I will provide you with information about both types and leave you to choose which is most suitable to you.

Ink used for animal painting has to be thick and dark and you need plenty of it. If you are using ground ink, be sure to make a large quantity of dark, thick ink. Ink dries up easily. It can be very frustrating if you have to stop halfway through painting an animal because you have run out of ink and then have to spend quite some time to make a fresh batch in order to resume your painting. For convenience I would suggest readers use liquid ink, at least for learning and practicing.

USING INK STICKS

For those who would like to make ink with an ink stick, you will also need an ink stone. A traditional ink stone is made of a kind of stone similar to slate, but much harder. Modern ink stones can be made from various materials, including stone, agate, ceramic, plaster, and even jade. The price of an ink stone can vary from $3 to over $30,000. Though the quality of an expensive one is always better, a cheaper one will serve the purpose equally well. There are many sizes available; always choose one that allows the ink stick to move comfortably on it in a circular motion. Alternatively, you can use an unglazed ceramic bowl instead of an ink stone. When I was a pupil to my first master, he gave me a ceramic bowl to start with because I was not considered worthy to use an ink stone yet. I still use this bowl for grinding my ink and it has now served me for more than fifty years.

As for ink sticks, prices also vary from less than $1.50 to about $75.00. Antique ink sticks are priced at well over $1,500. Ink sticks are classified by name, which is usually

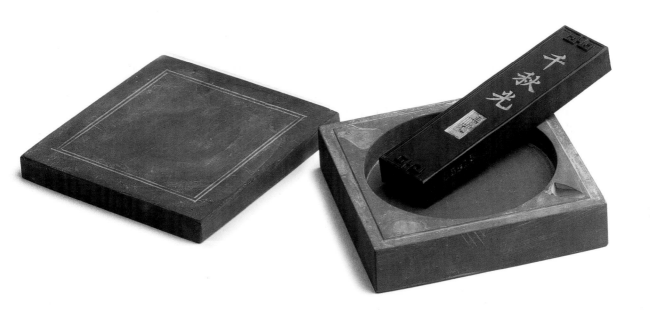

engraved on the stick. The most basic ones available in the U.S. are called Qian Qiu Guang (千秋光) and Zi Yu Guang (紫玉光). These ink sticks are usable, but their qualities are certainly not remarkable. However, they are perfectly fine for anyone who is just starting Chinese painting.

Tie Zhäi Weng (鐵齋翁書畫寶墨) is an ink stick of much better quality. It is also much more expensive. Unfortunately, there are many low-quality imitations of this particular ink stick offered at lower prices on the market. Also available are many other ink sticks with beautiful pictures engraved on them. These are more for presentation than an indication of quality, as they are more or less the same as the two I first mentioned.

If you want to make ink with an ink stick, this is how you make it: First place your ink stone or ceramic bowl on a level surface and then use your brush or an eyedropper to place a few drops of clean water on the surface of the ink stone. Hold the ink stone or bowl with one hand so that it will not move around when you are grinding the ink stick on it. Hold the ink stick with the other hand, placing it vertically on the water drops and grinding against the surface of the stone in a circular motion. You will see dark ink starting to appear. Add a few more drops of water and grind again. Repeat the process of adding a few drops of water, followed by grinding, until you have made sufficient dark ink. It is not advisable to grind the ink stick on a large pool of water. It will take a long time to turn the

An ink stick and an ink stone. You may also use an unglazed ceramic bowl for mixing your ink.

large pool of water into thick ink. Besides, thick ink dries up quickly. Test the darkness of the ink from time to time to see whether it is sufficiently dark and thick for your use. When you finish grinding, do not rest the wet part of the ink stick on the ink stone or it will stick to the stone when it dries. When the ink you prepared has almost run out, repeat the grinding process again. Always clean the ink stone every time after use. Any dry leftover ink on the stone will be very difficult to remove. Clean the stone with soft tissues and cold water. Dry it properly before putting it away. Do not use any abrasives to clean the stone because hard and abrasive material will damage its delicate surface.

Many readers have asked me how to restore an ink stone that has hard crusts of leftover ink stuck on the surface. The following method may help you to remove most of the leftover ink, but it will not necessarily restore your stone to its original perfect beauty, which is why it is so important to clean the stone after use. Fill a large bowl with warm water. The water should not be hot, just warm enough to touch. Use an old plastic bowl, because the black ink may leave stains. Soak your ink stone in it. After ten minutes, use tissues or paper towels to slowly wipe away the top layer of ink, which by now should have softened. Soak the ink stone again for ten more minutes and again wipe off the softened ink with soft papers. Repeat the process of soaking and wiping to remove as much leftover ink as possible. Wear waterproof gloves when you do this, because the dark ink will stain your hands. If the water gets cold, you can pour it out and refill the bowl with clean warm water. However, it is not essential to change the water. When you have removed as much leftover ink as you can, rinse the ink stone and wipe it with paper towels. Leave it to dry before storing it.

USING LIQUID INK

If you are going to use liquid ink, it is more economical to buy a large bottle than a small one. There are many manufacturers of quality liquid ink in China. A reliable one is made by Yi De Gë, which is probably the oldest ink maker in China. This company makes many types of ink, including liquid as well as sticks, with different qualities. Its liquid ink for general use is shown in the photograph on page 31. This is the most basic type. The same manufacturer also produces better qualities of ink. Some of its finest liquid inks are stored and sealed in porcelain jars and these are fast becoming collector's items.

Ink intended for writing is unsuitable for Chinese brush painting, because it bleeds wildly and you can't create dry brushwork with it. Chinese ink has gum in it and it is permanent on paper or fabric once it dries. For this reason you are advised not to wear your best clothing when using Chinese ink, as you will not be able to remove any splashes.

It is best to pour liquid ink into a separate container for painting. If your mixing dish has several compartments, use one compartment exclusively for ink. Alternatively, you can use the traditional ink stone, a small ceramic dish or even a small plastic container. Make

sure that you clean the ink dish every time you finish painting. Any leftover ink will harden and become very difficult to remove.

When freshly poured out of the bottle, liquid ink may be a bit thin, but it will thicken up very quickly if it is left in the open air. I usually allow fresh ink to stand for five to ten minutes before using it. For the same reason, you should pour out only a small amount of ink every time and add to it when it is running out. If the ink becomes too thick, you can add a bit of fresh ink to thin it. Adding water will make it paler, so always add fresh ink for thinning purposes if you want dark ink for painting.

I have used ready-made liquid ink for all the examples and artworks in this book. The following are some terms I use:

Dark ink. This is ink that has been freshly poured out of the bottle and has not been left in the open for too long. Dark ink is suitable for general painting.

Diluted ink. Water can be added to the dark ink. The more water you add, the lighter the ink will become. Diluted ink is used for general painting and for shading. It is often used to add tones.

Medium ink. A tiny bit of dark ink can be added to diluted ink to make it darker. You can create medium ink of different tones by controlling the amount of dark ink you add.

Thick ink. This is dark ink that has been left in the open for some time to thicken up. Thick ink is useful for creating dry brushwork and I use this consistency frequently in animal painting.

A bottle of liquid ink, manufactured by Yi De Gë, one of the oldest ink makers in China.

COLORS

There are many types of color that are suitable for Chinese brush painting. Ones especially made for this purpose are usually manufactured in China, Japan, or Korea. They come in either powder or crystal form. You have to prepare the powder colors with gum before use, whereas crystals have gum pre-mixed into them. There are also colors that come either in trays or tubes.

Some people insist on using colors manufactured in China or Japan for Chinese painting. Personally, I see no reason why Western watercolors shouldn't be used. Most of my pupils use these with excellent results, and there is the added advantage that Western watercolors are widely available and there is a good range.

The following is a list of essential colors used in this book (you can, of course, add any of your favorites to the list):

> sap green indigo burnt sienna gamboge yellow ochre
> cadmium yellow cadmium orange cadmium red deep
> alizarin crimson permanent rose cobalt blue Chinese white

Please feel free to use any of the Chinese, Japanese, or Korean colors, but remember to follow the manufacturer's instructions when using them.

Sap green

Gamboge

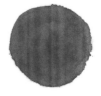

Burnt sienna

Indigo

OTHER ACCESSORIES

In addition to the brushes and colors, you will need the items listed below, most of which you will already have around the house.

- A big jar or a plastic container for water—if you prefer, you can have a few jars, so you don't have to keep changing to clean water.
- A mixing dish with a few compartments or, alternatively, a big light-colored dinner plate; if you use a plate for mixing colors, you will also need to use a small container or an ink stone for your ink.
- Lots of newspaper, to protect the surface you are painting on.
- A large-sized clean (unused) sheet of newsprint on which to lay your Xuan paper. This is needed to absorb excess moisture during painting. When the newsprint gets too wet and muddy, you can change to a fresh one. Traditionally, Chinese artists used to lay their painting paper on a large piece of flannel. Flannels produced for this purpose are available in art shops that stock Chinese painting materials. You can, however, just get a large piece of flannel from a fabric shop. Personally, I find that flannels are too soft and can be a hindrance to any expressive movement. Newsprint serves the same purpose well, but you have to change it frequently. Most art or craft shops stock newsprint, but usually in very small sizes. Look for A1 sheets. If these are not in stock, the shop can easily order them for you, and you will find it cheaper to buy in bulk.
- Small stones or brass weights, to keep your painting paper from moving when you are painting.
- A cheap painting brush or an old Chinese brush for mixing colors.
- A few wide shallow containers, such as shallow bowls or small wide plastic containers, for mixing washes—they should be wider than the width of your Hake brush.
- Paper towels for wiping brushes dry, because you are going to be using dry brushes a lot to capture the texture of fur.

Cobalt blue

Permanent rose

Alizarin crimson

Cadmium red deep

2 BASIC TECHNIQUES

Non-outline animal painting using the Chinese brush is a very expressive art form. If you are a beginner, you may find that your hands are hesitant, and not moving as you wish. Don't worry, everybody starts off like this. Constant practice with the brush will soon improve your skills. The important thing is to understand your brush, getting to know how it works. Combine this with plenty of practice, and your confidence will soon grow.

I am going to cover all the basic techniques in this chapter without going into details about the different applications. When we begin to paint the animals in the next chapter, I will show you all the variations used for painting animals. You will then be using the basic techniques explained here and combining brushstrokes as well as expanding them to develop further techniques to suit each project.

MANEUVERING CHINESE BRUSHES

If you don't have much experience of using a Chinese brush, this is where you start. Your first step is to learn how to hold the brush correctly. Then you will learn how to use it effectively. Simple details, such as the angle of the brush to the painting surface and the direction in which you move the brush all contribute to the final outcome. It may be confusing to learn so many things at the beginning, but don't give up. Constant practice with your brush will soon improve your skills.

ANATOMY OF A CHINESE BRUSH

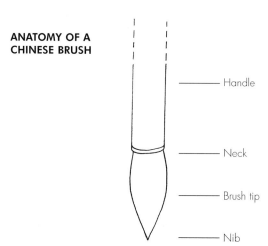

— Handle

— Neck

— Brush tip

— Nib

HOLDING THE BRUSH

The length of the handle of a Chinese brush is carefully measured in proportion to the size of the brush tip and with regard to the way the brush is intended to be used. For example, a brush made with black hair has a longer handle in comparison to a brush that is the same size, but made with a different type of hair. A black-hair brush is made for expressive painting, and therefore needs a longer handle, so that you can swing the brush during painting to achieve sweeping brushstrokes.

The normal way to hold a brush is to hold it at the middle of the handle. Experienced artists sometimes vary the position for special effects. For newcomers to the Chinese brush, it is better to start with the middle position. When you are more comfortable with the brush, you can then experiment with different positions.

When you hold the brush at the middle of the handle, your arm will always be positioned away from the painting surface. This gives you freedom to move your hand and arm in any direction without being restricted. Freedom of movement is essential for expressive painting. However, when you are using a slender brush to paint detailed features, such as the eyes, nose, and mouth of an animal, you may need some support to keep your hand steady. I will show you a way to deal with this later.

The simplest way to hold a brush is between your thumb and your four fingers. Another way is to hold it with two fingers on one side of the brush and the other two fingers on the same side as the thumb. You can use whichever way makes you comfortable, as both enable you to hold the brush upright and firmly. Always hold a brush in an upright position, varying the angle of the brush to the paper by rotating your wrist. Hold your brush firmly when you paint; this way you will produce brushwork with strength.

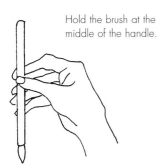

Hold the brush at the middle of the handle.

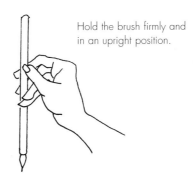

Hold the brush firmly and in an upright position.

One way of holding the brush is with four fingers on one side of the brush and the thumb on the other side.

Another way is to hold the brush with two fingers on one side and two fingers on the same side as the thumb.

ANGLE OF THE BRUSH TO THE PAINTING SURFACE

You can hold your brush either in a vertical position or at an angle to the painting surface, rotating your wrist to vary the angle of the brush to the paper. The angle often affects the outcome of the brushwork. For example, if you hold a brush loaded with ink at a high angle and touch the paper, the mark it makes is small because the contact area between the brush and paper is small. The brushmark will be larger if you hold the brush at a low angle because the contact area between brush and paper is proportionally larger.

Remember always to adjust the angle by rotating the wrist: do not use your fingers to adjust the angle because you will end up holding the brush loosely, which results in loose, floppy work.

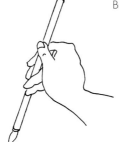

Brush held at a high angle to the paper.

A small brushmark
Dip the size 3 Leopard and Wolf brush into ink. Hold it at a high angle and touch the paper.

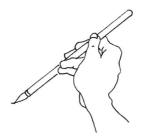

Brush held at a low angle.

A larger brushmark
Dip your size 3 Leopard and Wolf brush into the ink. Hold it at a low angle and touch the paper.

DIRECTION OF THE BRUSH

The rotation of the wrist not only controls the angle of the brush to the painting surface, but it also controls the direction in which the tip of the brush points. This page illustrates the most common directions. For each direction, I have demonstrated how both a right-handed and a left-handed person should hold the brush. As I am right-handed, the other illustrations in this book will simply show the right-handed position, so left-handed readers will need to adjust accordingly.

The position of the tip of a brush controls the shape of many brushstrokes. For example, if you hold your brush loaded with ink at an angle to the paper, with the tip of the brush pointing to the left, and then press the brush on the paper, the resulting brushmark will have a narrow end pointing to the left. The narrow end of the brushmark will point to the right if you point the tip of the brush to the right when you paint. It is important to know the shapes of your brushstrokes, because these shapes make up the contours of the body of the animal you are painting.

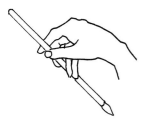

Holding the brush with the tip of the brush pointing to the right (for right-handed readers) and the handle pointing to the left.

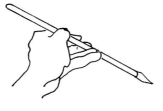

Holding the brush with the tip of the brush pointing to the right (for left-handed readers).

A brushmark with the narrow end pointing to the right.

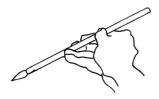

Holding the brush with the tip of the brush pointing to the left (for right-handed readers) and the handle pointing to the right.

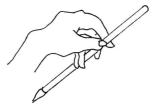

Holding the brush with the tip of the brush pointing to the left (for left-handed readers).

A brushmark with the narrow end pointing to the left.

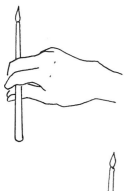

Holding the brush with the tip of the brush pointing away from you (for right-handed readers) and the handle toward you.

A brushmark with the narrow end pointing away from you.

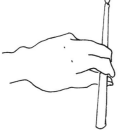

Holding the brush with the tip of the brush pointing away from you (for left-handed readers).

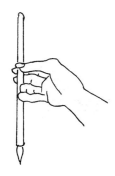

Holding the brush with the tip of the brush pointing toward you (for right-handed readers) and the handle pointing away from you.

A brushmark with the narrow end pointing toward you.

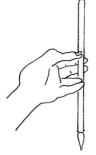

Holding the brush with the tip of the brush pointing toward you (for left-handed readers).

DIRECTION OF THE HANDLE OF THE BRUSH

Some brushstrokes in animal painting need to convey a sense of swift movement and must be painted rapidly. It is more natural, and actually easier, to move the brush in the direction in which the handle is pointing when you want to paint this sort of brushstroke. For example, when you paint the tail of a running horse flowing to the right, hold the brush at an angle to the paper so that the handle is pointing to the right, then paint the tail by moving the brush quickly from left to right, in the direction in which the handle is pointing. You can see that the resulting brushstroke is smooth and flowing. However, if you want to paint the tail flowing toward the left, but you are still holding the brush with the handle pointing to the right, and you move the brush in the opposite direction, that is from right to left, your movement will go against the loose hair at the tip of the brush, and the resulting brushwork will appear hesistant. This will spoil the flowing effect of the brushstroke. Some artists make use of the effect created by moving against the loose hair of the brush, but I will not be using this effect in this book.

Sometimes, you have to change direction during a long brushstroke. For example, when you are painting a snake, you have to change direction a few times to show the coil of the body. To make this kind of brushwork effectively, always rotate your wrist to adjust the direction of the handle of the brush so it points in the direction of the painting movement.

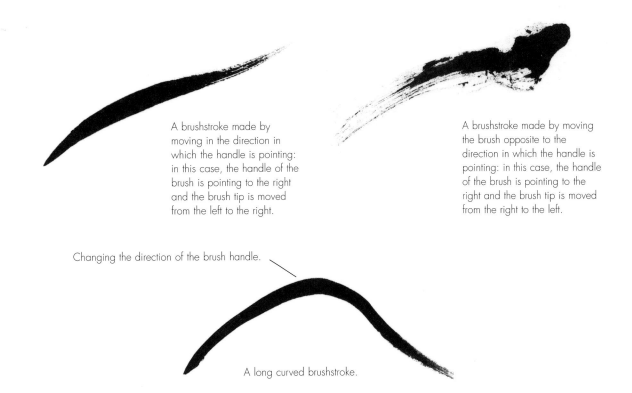

A brushstroke made by moving in the direction in which the handle is pointing: in this case, the handle of the brush is pointing to the right and the brush tip is moved from the left to the right.

A brushstroke made by moving the brush opposite to the direction in which the handle is pointing: in this case, the handle of the brush is pointing to the right and the brush tip is moved from the right to the left.

Changing the direction of the brush handle.

A long curved brushstroke.

LOADING A BRUSH WITH INK OR COLORS

You load a brush with ink or colors to paint. Below are some of the terms I use in this book to refer to loading a brush.

Fully Loading a Brush

Dip the whole tip of a brush into ink or a color until it is saturated. If there is too little color in the palette, or if this is too shallow or the brush too large, hold the brush so that the brush is laid on its side. Roll the tip of the brush until it is saturated with color. Next, hold the brush at an angle to the paper and touch the paper. The paper will absorb the moisture and the brushmark usually runs.

If you fully load a large brush, such as the large Bear-hair brush, you have to prepare much more color than usual because a large brush will soak up a lot of moisture. If a large brush is not fully loaded, the brushstrokes it makes will have blank spaces.

An ink brushmark using a fully loaded small Orchid and Bamboo brush, held at an angle to the paper.

An ink brushmark using a fully loaded large Bear-hair brush, held at an angle to the paper.

Dipping the Nib in Color or in Ink

Here, you load only the nib of the brush with ink or color. This will limit the amount of moisture held by the brush, so the resulting mark will be smaller.

Throughout the book, I have used the Red Bean brush and diluted ink to draw the initial outlines of animals. I wanted the initial outlines to be thin, so I dipped only the nib of the brush into diluted ink. Overloading the Red Bean brush with diluted ink will simply make your outlines thicker.

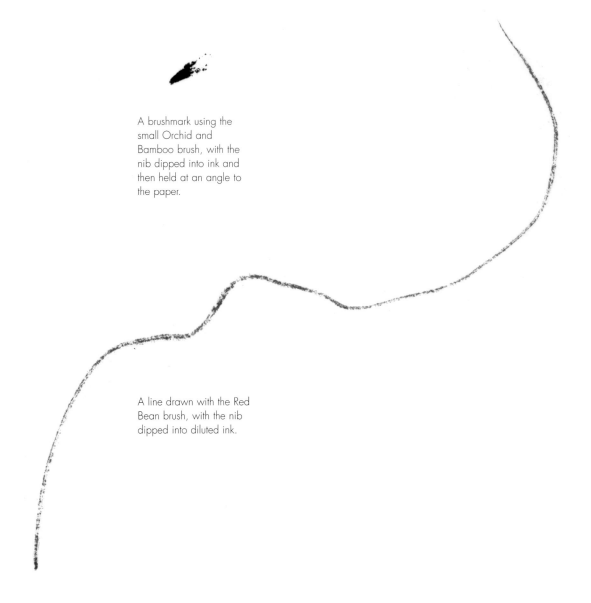

A brushmark using the small Orchid and Bamboo brush, with the nib dipped into ink and then held at an angle to the paper.

A line drawn with the Red Bean brush, with the nib dipped into diluted ink.

Normal Loading

The normal way of loading a brush is to fully load a brush with a color and then gently wipe off excess moisture at the edge of the color dish. I generally use normal loading when I apply color to paint the bodies of animals. A tip for coloring animals: you have to keep the brush moving at a steady speed. Never let the brush stay on one spot for too long or the paper will absorb the moisture from the brush. This will create unwanted bleeding of colors beyond your intended outline.

When you are using the Outline brush for drawing the delicate features of the animals, such as the faces and feet, do not load just the nib of the brush, but use normal loading. The Outline brush is designed to create thin lines, even with normal loading. If you load only the nib of an Outline brush with ink or color, it will not last very long and you will have to keep loading it again and again in order to finish the drawing. Also, in order to create more striking and delicate features, such as the face, with the Outline brush, use thicker ink. After pouring it out of the bottle, leave the ink in the open for about five to ten minutes to thicken before you use it.

A brushmark painted using normal loading
Fully load the small Orchid and Bamboo brush with ink and wipe off excess moisture at the side of the palette. Hold the brush at a high angle to the paper, and then press and draw a line.

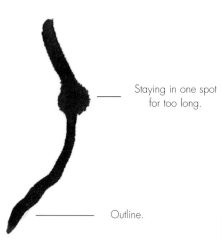

Staying in one spot for too long.

Outline.

Bleeding beyond the outline
This is what happens if you let the brush stay in one spot so the paper soaks up the moisture. Notice how the color bleeds beyond the outline.

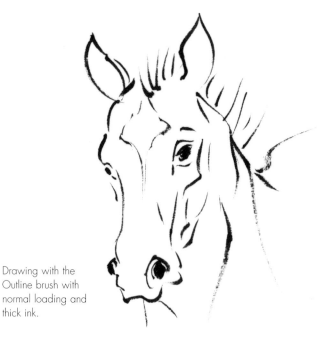

Drawing with the Outline brush with normal loading and thick ink.

Dry Loading

For drier brushwork, load a brush with a color and wipe off excess moisture on a tissue or paper towel. The more moisture you wipe off, the drier the resulting brushstroke.

A drier brushmark
Load the small Orchid and Bamboo brush with dry loading. Holding the brush at an angle to the paper, press and paint a brushstroke.

Broken Brushstrokes

After dry loading the brush with color, press it on the palette until the hairs separate. The resulting brushstroke will have lines, with blank spaces in between. We call this brushstroke a broken brushstroke. Make sure you press the brush on the palette. Do not press the brush on paper towel or any absorbent surface, because this will absorb most of the moisture, leaving less than you intended in the brush. In order to make the broken brushstrokes more effective, use thicker ink and color.

We frequently use broken brushstrokes when creating animal hair and fur. I shall deal with this special technique in greater detail in the next chapter.

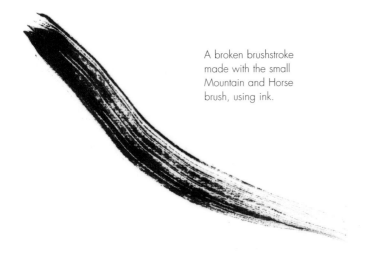

A broken brushstroke made with the small Mountain and Horse brush, using ink.

Two-Tone or Two-Color Loading

Two-tone and two-color loading are popular techniques in animal painting. The nib of the brush controls the arrangement of colors. The darker color or tone is usually loaded onto the nib of the brush. It is important to position the nib of the brush in the right place so that the eventual brushwork will have the correct colors in the planned arrangement.

Two-tone loading
Fully load a small Orchid and Bamboo brush with diluted burnt sienna and then dip the nib of the brush into undiluted burnt sienna. Hold the brush at a low angle, with the nib of the brush pointing to the left, and then press. The resulting brushmark will show a gradual toning of the color. Note that the darker tone of burnt sienna is at the point where the nib touches the paper.

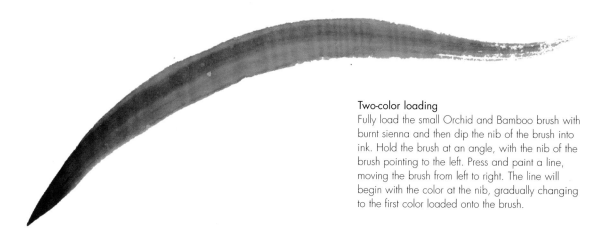

Two-color loading
Fully load the small Orchid and Bamboo brush with burnt sienna and then dip the nib of the brush into ink. Hold the brush at an angle, with the nib of the brush pointing to the left. Press and paint a line, moving the brush from left to right. The line will begin with the color at the nib, gradually changing to the first color loaded onto the brush.

PAINTING FEATURES

When you use the Outline brush to paint features, such as the eye, nose, or mouth of an animal, the lines have to be thin and accurate. You need a steady hand for this, which is difficult if you have not been using a Chinese brush for very long. The following two methods will help.

Method 1

Hold your brush at a lower position along the handle so that your wrist touches the paper. This gives you extra support for your hand. Be careful, or your wrist may accidentally touch the wet color during the painting process and mess up your brushwork.

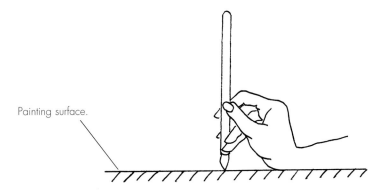

Painting surface.

Method 2: the Cushion Method

Hold the brush in the usual way, at the middle of the handle. Lay the arm of your other hand on the painting surface, next to the area where you are going to paint. Then rest the arm of your brush-holding hand on your wrist. This will give you extra support while allowing you freedom to move, because you can slide your arm along the hand that is lying on the painting surface. I prefer this method, because your hand will not interfere with your brushwork.

This technique has been used for a long time. I cannot recall any master giving it a name, however, so I am calling it the cushion method, which will make it easy to refer to later on in the book.

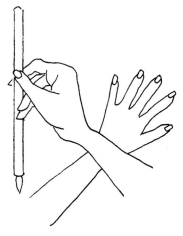

Cushion method.

WRIST AND ELBOW MOVEMENT

The Chinese non-outline style is a very expressive way in which to paint animals. It requires that our hands and arms move without hesitation. These fluid movements create the dynamic atmosphere of the final artwork. Not many people are used to actively moving their hands and arms when painting, so at first you may find your joints are very stiff and reluctant. In order to get you into the habit of moving freely and actively, let's start with two movements: wrist movement and elbow movement.

WRIST MOVEMENT

Wrist movement is made by rotating the wrist. We have discussed how, by rotating the wrist, we can vary the angle between the brush and the paper and also control the painting movement by positioning the direction in which the handle of the brush points. In this section, we are going to learn how to move the brush by rotating the wrist. The movements made by rotating the wrist are small, so brushstrokes made with wrist movements are restricted. They are useful for the more precise and smaller strokes, such as those needed for the features of an animal's face and its paws.

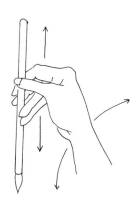

Wrist movement
You can move your hand up or down and to the right or left by rotating the wrist.

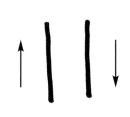

Short vertical lines
Load the size 3 Leopard and Wolf brush with a normal loading of ink. Holding the brush in the vertical position, draw short vertical lines. Move your hand upward and downward with the wrist, following the directions indicated by the arrows.

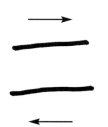

Short horizontal lines
Load the size 3 Leopard and Wolf brush with a normal loading of ink. Hold the brush in a vertical position and draw short horizontal lines. Move the hand to the right or to the left with the wrist, following the directions indicated by the arrows.

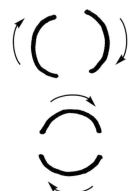

Small curves
Load the size 3 Leopard and Wolf brush with a normal loading of ink. Hold the brush in a vertical position and draw the small curves. Move the brush, following the directions indicated by the arrows above.

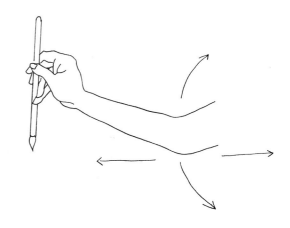

ELBOW MOVEMENT

You can also move your brush by rotating your arm at the elbow. In this way, you can move your arm forward or backward and you can also swing it to the left or right. Elbow movements enable you to create longer brushstrokes. When elbow movement is used with speed, the resulting brushwork is very dynamic. We always use this type of sweeping brushwork to express the movements of animals.

Elbow movement
Move your arm forward or backward and to the left or right by bending or rotating the elbow.

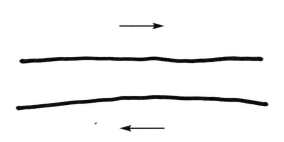

Long horizontal lines
Load the size 3 Leopard and Wolf brush with a normal loading of ink. Hold the brush in a vertical position. Draw long horizontal lines by moving your arm to the left or right, using elbow movements and following the directions indicated by the arrows.

Long vertical lines
Load the size 3 Leopard and Wolf brush with a normal loading of ink. Hold the brush in a vertical position. Draw long vertical lines by moving your arm forward and backward, using elbow movements and following the directions indicated by the arrows above.

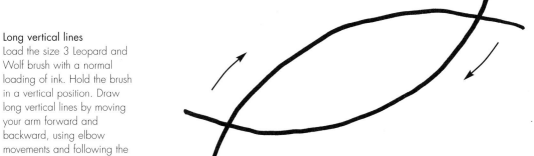

Long curves
Load the size 3 Leopard and Wolf brush with a normal loading of ink. Hold the brush in a vertical position. Draw long curves by moving your arm, as indicated in the illustrations.

EXERCISES

We generally have to use a combination of wrist and elbow movements in Chinese animal painting. Here are some exercises to help you to practice these two movements. I used the Red Bean brush and ink to sketch the illustrations here. To draw thicker lines, such as the markings on the tiger's face, use multiple thin lines to make up the thickness.

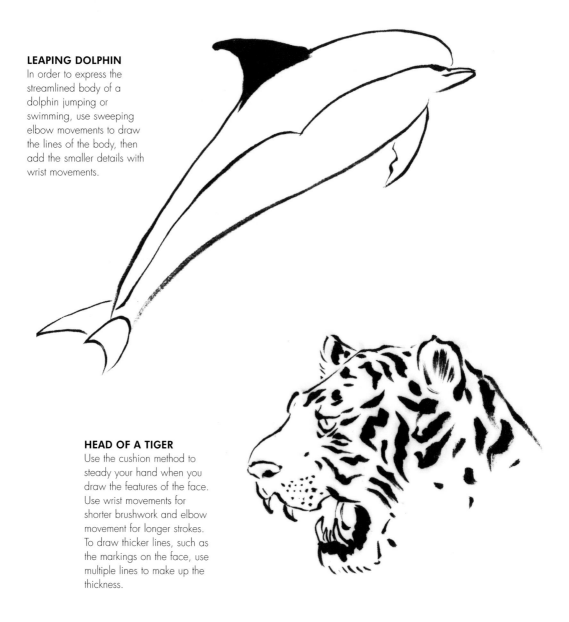

LEAPING DOLPHIN
In order to express the streamlined body of a dolphin jumping or swimming, use sweeping elbow movements to draw the lines of the body, then add the smaller details with wrist movements.

HEAD OF A TIGER
Use the cushion method to steady your hand when you draw the features of the face. Use wrist movements for shorter brushwork and elbow movement for longer strokes. To draw thicker lines, such as the markings on the face, use multiple lines to make up the thickness.

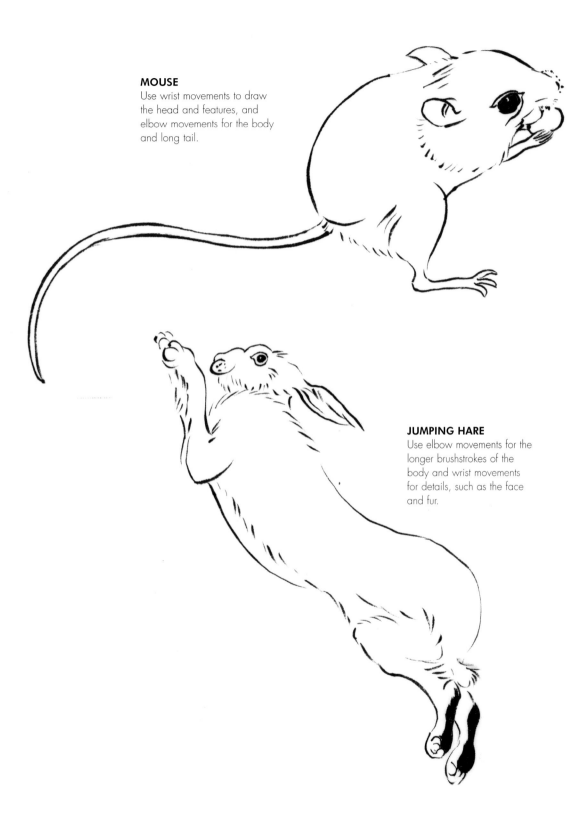

MOUSE
Use wrist movements to draw the head and features, and elbow movements for the body and long tail.

JUMPING HARE
Use elbow movements for the longer brushstrokes of the body and wrist movements for details, such as the face and fur.

PRESS-AND-LIFT TECHNIQUE

When you press the brush the hairs at the tip spread and create width in your brushwork. When you lift the brush, the tip will go back to the original pointed shape and the resulting brushwork will be thinner. By pressing and lifting the brush, you can vary the widths at different parts of a single brushstroke.

Combining the press-and-lift technique with wrist and elbow movements, you can create small and large brushstrokes of different widths and lengths. In the non-outline style of painting, an animal is made up of many brushstrokes. Each will be different in shape and size, according to how much you press or lift the brush, whether you use wrist or elbow movements, how high or low you hold the angle of the brush to the paper, and how you maneuver the brush in changing the direction of the handle. These brushstrokes will build the shape, muscle, and body, and suggest the movement as well as the character of an animal.

PRESS-AND-LIFT TECHNIQUE WITH WRIST MOVEMENT

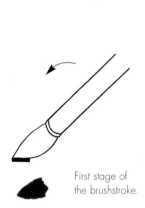

First stage of the brushstroke.

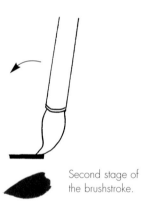

Second stage of the brushstroke.

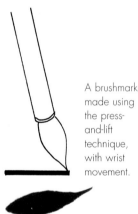

A brushmark made using the press-and-lift technique, with wrist movement.

STEP 1
Fully load the small Orchid and Bamboo brush with dark ink. Hold the brush at a fairly high angle to the paper. Point the handle of the brush in the direction in which your movement will be going. I am positioning the handle pointing to the right in this illustration. Press at the beginning of the shape.

STEP 2
Rotate your wrist in a counterclockwise direction so that the handle of the brush rotates, with the wrist moving the tip of the brush from left to right.

STEP 3
Lift the brush gradually as you move to the right toward the end of the shape, until it leaves the paper.

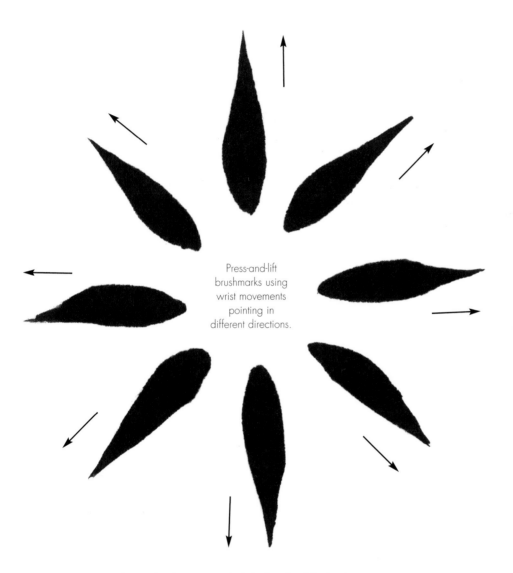

Press-and-lift
brushmarks using
wrist movements
pointing in
different directions.

By adjusting the direction in which the handle of the brush points,
you can angle the shape to point to different directions. The arrows
indicate the direction in which the handle of the brush points at the
beginning of the brushstroke.

PRESS-AND-LIFT TECHNIQUE
WITH ELBOW MOVEMENT

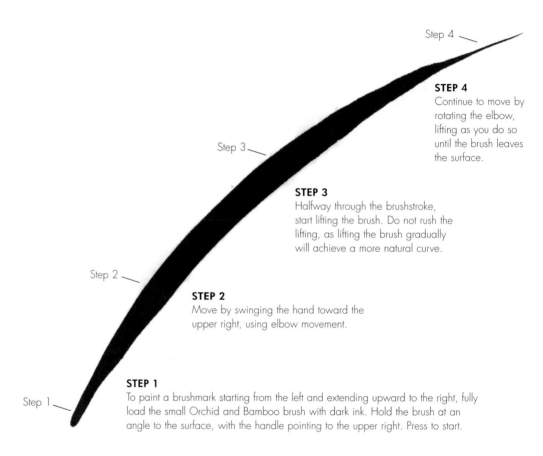

Step 4

STEP 4
Continue to move by
rotating the elbow,
lifting as you do so
until the brush leaves
the surface.

Step 3

STEP 3
Halfway through the brushstroke,
start lifting the brush. Do not rush the
lifting, as lifting the brush gradually
will achieve a more natural curve.

Step 2

STEP 2
Move by swinging the hand toward the
upper right, using elbow movement.

STEP 1
To paint a brushmark starting from the left and extending upward to the right, fully
load the small Orchid and Bamboo brush with dark ink. Hold the brush at an
angle to the surface, with the handle pointing to the upper right. Press to start.

Step 1

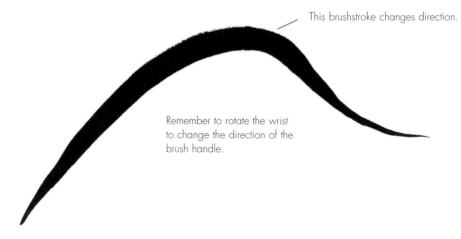

This brushstroke changes direction.

Remember to rotate the wrist
to change the direction of the
brush handle.

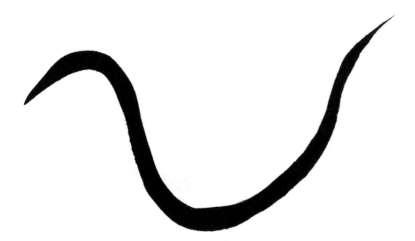

For a very long press-and-lift brushstroke, such as the one used for the long, wriggling body of a snake, it is more convenient to use a large brush, because you can load more color onto the brush to sustain a longer brushstroke. If you are using a smaller brush the color on the brush may run out and you will have to reload the brush halfway through painting. I painted this brushstroke with the large Bear-hair brush. However, remember to keep moving the brush at a steady speed. If you let the brush stay in one spot for too long, the paper will absorb moisture from the big brush and the color will bleed beyond control.

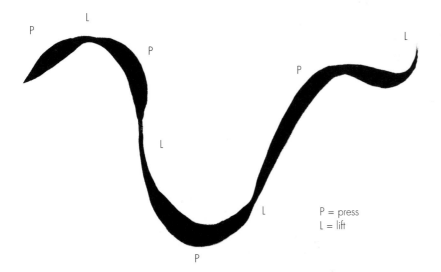

P = press
L = lift

This long brushstroke is made up of long and short press-and-lift brushstrokes at different intervals. Use wrist movements for the short strokes and elbow movements for the long ones. You will often use this type of brushstroke when painting animals: For example, to paint the pattern on an animal's body.

EXERCISES

Press-and-lift brushwork is essential to the non-outline style of animal painting. Almost every brushstroke used for building the body involves the press-and-lift technique. Here are some exercises to help get you started.

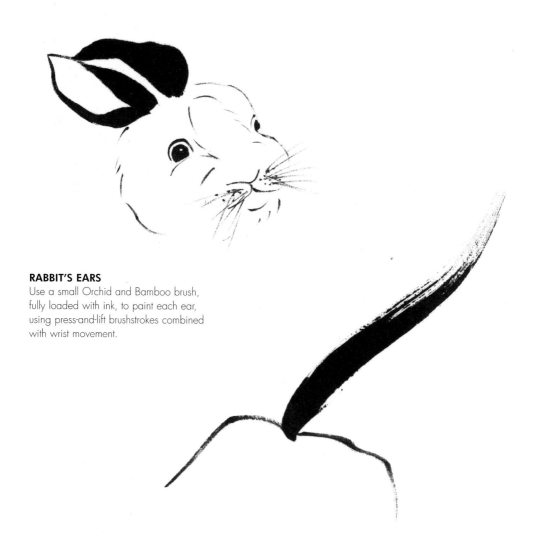

RABBIT'S EARS
Use a small Orchid and Bamboo brush, fully loaded with ink, to paint each ear, using press-and-lift brushstrokes combined with wrist movement.

HORSE'S TAIL
A simple press-and-lift brushstroke with elbow movement, made with the small Mountain and Horse brush and ink, creates a horse's tail.

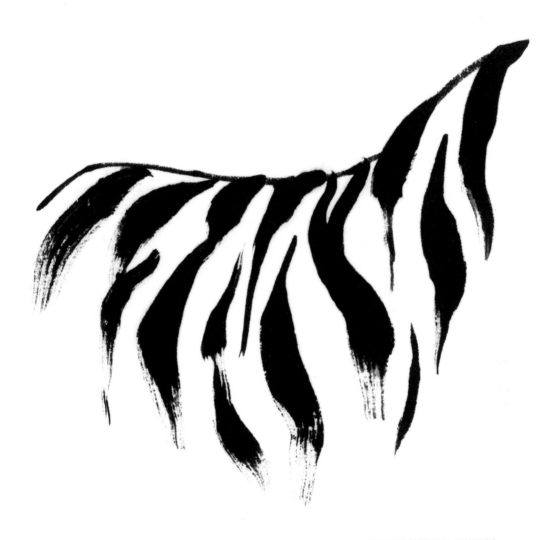

TIGER'S BODY MARKINGS
Every mark on a tiger's body
varies in width and length. Use
a combination of wrist and elbow
movements, together with the
press-and-lift technique, to create
a range of markings.

USING BRUSHES ON THE SIDE

When you hold the brush at a low angle to the paper, the side of the brush tip touches the paper. Using the side of the brush is popular in painting, because this enables the brush to cover a wider area. By holding the brush at different low angles to the paper, we can create different sizes of side brushstrokes. The range can be extended further by using different sizes of brush. The key to using this section is to not restrict yourself simply to the brush I have suggested for an illustration, but to experiment with brushes of other sizes.

The brushstrokes I am going to show you in this section are long dots, extended long dots, straight side brushstrokes, curved side brushstrokes, side brushstrokes made with the press-and-lift technique, fan brushstrokes and reverse fan brushstrokes. It is important to bear in mind that if you load your brush with either two or more colors or tones of the same color, the effect you make very much depends on where you place the nib of your brush. Usually it is more convenient to load the darker tone or the darker color onto the nib of the brush, so you must be sure you know exactly where you want to place the darker tone or color before you press your brush on the paper.

PAINTING DOTS

Long Dots

Fully load a brush with ink. Holding the brush at a low angle to the paper, so that the side of the brush tip is touching the paper, press the brush. The resulting mark has a narrow end where the nib of the brush touches the paper and a wider end where the neck touches the paper. We call this mark a long dot.

Painting surface.

Fully load the small Orchid and Bamboo brush with ink. Hold the brush at a low angle to the paper and paint a long dot. In this illustration, I held the brush with the nib of the brush pointing to the left, so the resulting mark narrows to the left.

A long dot.

DIFFERENT SHAPES OF LONG DOTS

By adjusting the position of the nib of the brush, you can create long dots of different shapes. The narrow end is always where the nib of the brush touches the paper.

The length of a long dot depends on the final angle between brush and paper. The lower the angle, the longer the long dot will be.

A small long dot is made when the brush is held at a higher angle.

When the brush is held at a lower angle, the dot is longer.

Long dots can be used for filling spaces and for building shapes. Because a long dot has a narrow end and a wide end, you can maneuver either one long dot or multiple dots to fit in any spare space that needs to be filled, which makes them especially useful when you need extra brushstrokes to finish building a shape. For example, in painting the head of a snake, two long dots are added to each side of the initial brushstroke to create its triangular shape.

The triangular head of a snake.

Extended Long Dots

If you slide the brush when you are painting a long dot in the direction in which the handle of the brush is pointing, the dot becomes even longer. We call this brushmark an extended long dot. Using wrist movement to slide results in a relatively short extended long dot, while elbow movement makes a longer extended long dot. This brushstroke is frequently used to paint the tails and legs of animals. If you are painting an extended long dot with elbow movement, it is more convenient to use a large brush, as this can hold more color and therefore go a longer way.

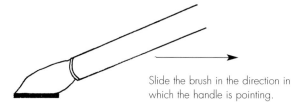

Slide the brush in the direction in which the handle is pointing.

An extended long dot using wrist movement.

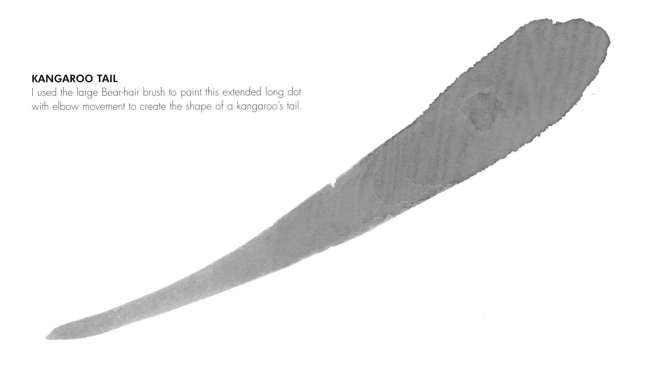

KANGAROO TAIL
I used the large Bear-hair brush to paint this extended long dot with elbow movement to create the shape of a kangaroo's tail.

Multiple long or extended long dots are frequently used to build up large areas of brushwork. Sometimes one brushstroke made with the large Bear-hair brush can create the desired effect, but some areas in animal painting are very large and you have to use more than one brushstroke to build them up, even when you are using a large brush.

A large long dot using the large Bear-hair brush.

Using a few extended long dots to build up a larger area.

SIDE BRUSHSTROKES

When you press a brush, the resulting brushwork will usually be wider, but for even wider areas, side brushstrokes are used. In animal painting, the many versions of side brushstrokes are popularly used for building up the contours of bodies. Side brushstrokes can be straight and vertical, horizontal, or at an angle. They can also be curved. You can also combine them with the press-and-lift technique to create press-and-lift side brushstrokes.

STRAIGHT SIDE BRUSHSTROKES

Straight side brushstrokes are useful for applying colors to the bodies of animals, especially if they are large. Straight side brushstrokes can be vertical, horizontal, or at an angle.

VERTICAL SIDE BRUSHSTROKES

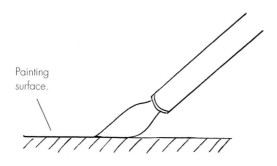

Painting surface.

STEP 1
Fully load a brush with ink or color. Hold the brush at an angle to the paper, with the handle pointing to the left or right. The brush is now lying on the side of the brush tip. Press the brush tip on the paper.

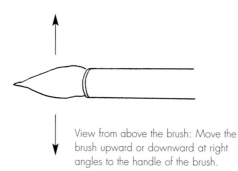

View from above the brush: Move the brush upward or downward at right angles to the handle of the brush.

STEP 2
Move the brush upward or downward at right angles to the handle of the brush to paint a side brushstroke. The brushwork created by moving the brush upward is similar in shape to the one created by moving the brush downward.

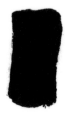

A vertical side brushstroke

The angle of the brush to the paper affects the width of the resulting side brushstroke. The lower the angle, the wider the brushstroke, because there is more contact between the brush and the paper. Similarly, the higher the angle, the narrower the brushstroke, because there is less contact. The length of a side brushstroke depends on the movement you use, being shorter when you use wrist movement and longer when you use elbow movement.

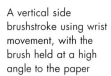

A vertical side brushstroke using wrist movement, with the brush held at a high angle to the paper

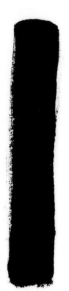

A vertical side brushstroke using elbow movement, with the brush held at a low angle to the paper

If you are loading the brush with only one tone of a color to paint a vertical side brushstroke, the result will be the same, whether you point the nib of the brush to the left or to the right. However, if you load the brush with two tones of a single color or two colors, the color arrangements of the resulting brushwork will depend on where you load the darker tone or the darker color onto the brush. It is easier to load the darker tone or the darker color onto the nib of the brush, which means that when you paint with two tones or two colors, the darker tone or color will appear where the nib of the brush touches the paper.

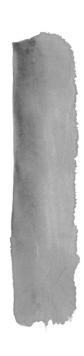

A vertical side brushstroke with two tones of a color

I fully loaded the small Orchid and Bamboo brush with diluted burnt sienna and dipped the nib of the brush into undiluted burnt sienna. I positioned the nib of the brush to point to the left at a low angle to the paper and painted a side brushstroke with elbow movement.

A vertical side brushstroke with two colors

I fully loaded the small Orchid and Bamboo brush with burnt sienna and dipped the nib of the brush into ink. I positioned the tip of the brush to point to the left, at a low angle to the paper, and painted a side brushstroke with wrist movement.

HORIZONTAL SIDE BRUSHSTROKES

Hold the brush at an angle to the paper, with the handle of the brush pointing either away from you or toward you. The brush tip is at a vertical position when you view it from above the brush. Move the brush sideways to the left or right in a straight direction. The results are horizontal side brushstrokes.

Again, the width of a horizontal side brushstroke depends on the angle at which you hold your brush to the paper and the length depends on whether you use wrist movement or elbow movement.

You can create straight side brushstrokes pointing in different directions as long as you move the brush tip at right angles to the direction of the handle. If you are using two-tone or two-color loading, with the darker tone or color at the nib of the brush, the darker tone or color will appear where the nib touches the paper.

View from above the brush: Move
the brush to the right or to the left in
a straight line, at right angles to the
handle of the brush.

A horizontal side brushstroke using wrist movement, with the brush at a high angle to the paper

A straight side brushstroke at an angle using elbow movement, with the brush at a low angle to the paper

A horizontal side brushstroke with two tones of a color
I fully loaded the small Orchid and Bamboo brush with diluted burnt sienna and dipped the nib of the brush into undiluted burnt sienna. I positioned the handle of the brush to point toward me at a low angle to the paper and painted a side brushstroke with elbow movement.

A side brushstroke at an angle with two colors
I fully loaded the small Mountain and Horse brush with burnt sienna and dipped the nib of the brush into ink. I positioned the handle of the brush to point at an angle halfway between the right and upward directions, with the brush tip at a low angle to the paper, and painted a side brushstroke with wrist movement.

CURVED SIDE BRUSHSTROKES

Hold the brush as if you were going to paint a horizontal side brushstroke, but instead of moving the brush in a straight line, move the brush in a curve. The result is a curved side brushstroke. If you use wrist movement, the curve is shorter; it is longer if you use elbow movement. The width of the curved side brushstroke depends on the angle of the brush to the paper. Curved side brushstrokes are very useful for applying colors to the body of an animal, as the majority of animals have curved bodies. When you apply colors to a body, place the nib of the brush on the outline of the body and paint the side brushstrokes, with the nib following the outline.

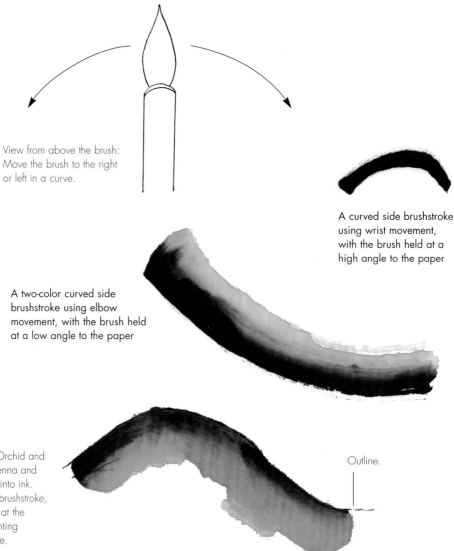

View from above the brush: Move the brush to the right or left in a curve.

A curved side brushstroke using wrist movement, with the brush held at a high angle to the paper

A two-color curved side brushstroke using elbow movement, with the brush held at a low angle to the paper

Applying colors to a body
I used a fully loaded small Orchid and Bamboo brush with burnt sienna and dipped the nib of the brush into ink. Then I made a curved side brushstroke, placing the nib of the brush at the outline of the body and painting brushstrokes along the outline.

Outline.

SIDE BRUSHSTROKES USING PRESS AND LIFT

If you press the brush to begin a side brushstroke and lift to finish, the side brushstroke has a wider end where you press the brush and a narrow end where you lift it. We use press-and-lift side brushstrokes when we have to fit in an area with a particular shape. For example, the upper part of the leg of an animal is wider than the lower part. So you start by pressing the brush at the wide end and then lift it at the narrow end.

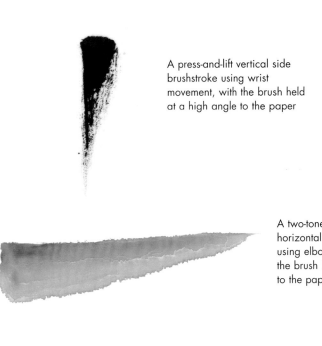

A press-and-lift vertical side brushstroke using wrist movement, with the brush held at a high angle to the paper

A two-tone press-and-lift horizontal side brushstroke using elbow movement, with the brush held at a low angle to the paper

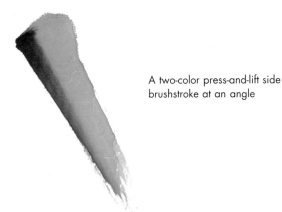

A two-color press-and-lift side brushstroke at an angle

EXERCISES

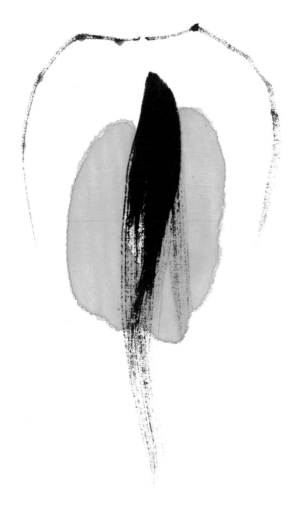

HORSE'S HINDQUARTERS

The body of an animal is usually rounded, so curved side brushstrokes are appropriate. To paint a horse's hindquarters, apply diluted burnt sienna to the inner part of the hindquarters. Load the brush with burnt sienna and dip the nib in ink. Place the nib at the outline of the hindquarters and paint a long curved side brushstroke along the outline to finish coloring.

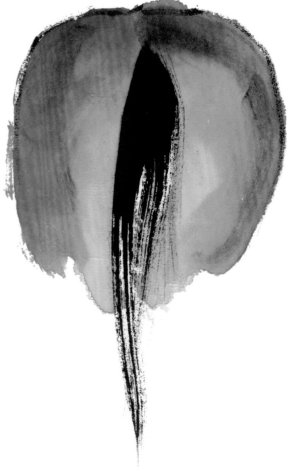

ELEPHANT'S LEGS
Use the small Mountain and Horse brush and two colors: burnt sienna and burnt sienna darkened with a little ink. Start with a vertical side brushstroke, using burnt sienna, and add another vertical side brushstroke with darkened burnt sienna, overlapping the two colors a little.

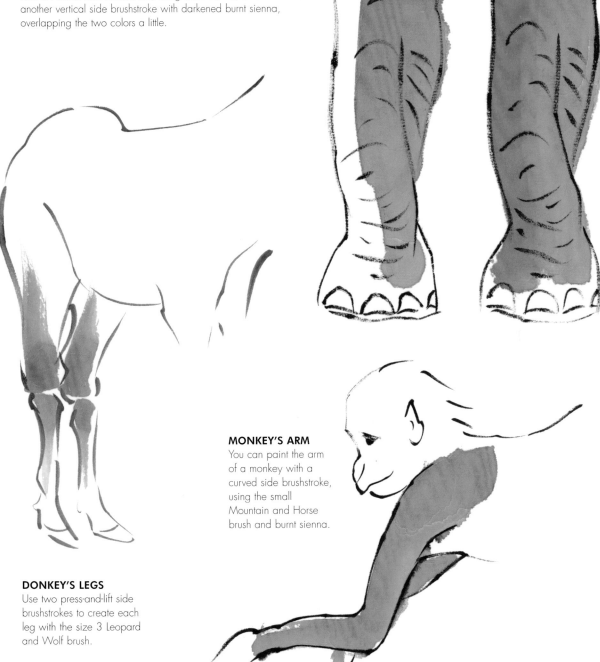

MONKEY'S ARM
You can paint the arm of a monkey with a curved side brushstroke, using the small Mountain and Horse brush and burnt sienna.

DONKEY'S LEGS
Use two press-and-lift side brushstrokes to create each leg with the size 3 Leopard and Wolf brush.

FAN BRUSHSTROKES

The length of a fan brushstroke or a reverse fan brushstroke varies according to the angle between the brush and the paper: the lower the angle, the longer the brushwork. However, it is more effective to use different sizes of brush to create different lengths of this brushstroke. You can control the width of the fan brushstroke by how far you move the neck of the brush, but the width of a reverse fan brushstroke is controlled by how far you move the tip of the brush. A small movement results in a narrow brushstroke, while a bigger movement makes a wider brushstroke.

You can start a fan brushstroke or a reverse fan brushstroke from the left or from the right and move in the opposite direction. Either way, the result will be the same.

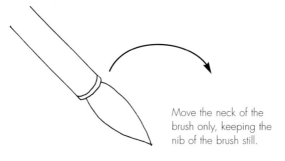

Move the neck of the brush only, keeping the nib of the brush still.

STEP 1
Fully load the size 3 Leopard and Wolf brush with ink or color and hold the brush at a low angle to the paper.

STEP 2
Using wrist movement, move the neck of the brush only and keep the nib of the brush still. The resulting brushwork is fan-shaped.

A narrow fan brushstroke, made with a small movement of the neck of the brush.

Width.

Length.

A bigger movement of the neck of the brush results in a wider brushstroke.

A fan brushstroke with two colors
Fully load the size 3 Leopard and Wolf brush with burnt sienna and dip the nib of the brush into ink. Hold the brush at a low angle to the paper, with the handle pointing toward you. Paint a fan brushstroke.

Multiple fan brushstrokes
Load the size 3 Leopard and Wolf brush with burnt sienna and dip the nib of the brush into ink. Paint a few fan brushstrokes side by side to make a bigger area of brushwork. When painting animals, you will generally need more than one fan brushstroke to make up an area of brushwork.

A large fan brushstroke, made with the large Bear-hair brush
You can use the large Bear-hair brush to paint larger fan brushstrokes. Load the large Bear-hair brush with burnt sienna and dip the nib of the brush into ink. Paint a fan brushstroke. Some areas of brushwork are very large, however, and you need more than one fan brushstroke to construct these, even with a larger brush.

PAINTING A REVERSE FAN BRUSHSTROKE

Wrist movement is again used to paint a reverse fan brushstroke, but instead of moving the neck of the brush, we move the nib of the brush and keep the neck of the brush still. In animal painting, reverse fan brushstrokes are used more often than the fan brushstrokes. Again, you can start a reverse fan brushstroke from the right or from the left and the result will be the same.

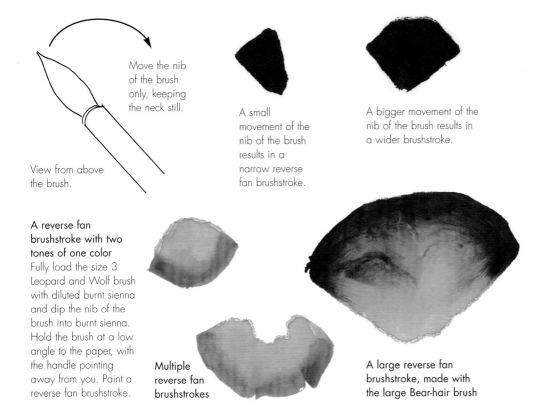

Move the nib of the brush only, keeping the neck still.

View from above the brush.

A small movement of the nib of the brush results in a narrow reverse fan brushstroke.

A bigger movement of the nib of the brush results in a wider brushstroke.

A reverse fan brushstroke with two tones of one color
Fully load the size 3 Leopard and Wolf brush with diluted burnt sienna and dip the nib of the brush into burnt sienna. Hold the brush at a low angle to the paper, with the handle pointing away from you. Paint a reverse fan brushstroke.

Multiple reverse fan brushstrokes

A large reverse fan brushstroke, made with the large Bear-hair brush

EXERCISES

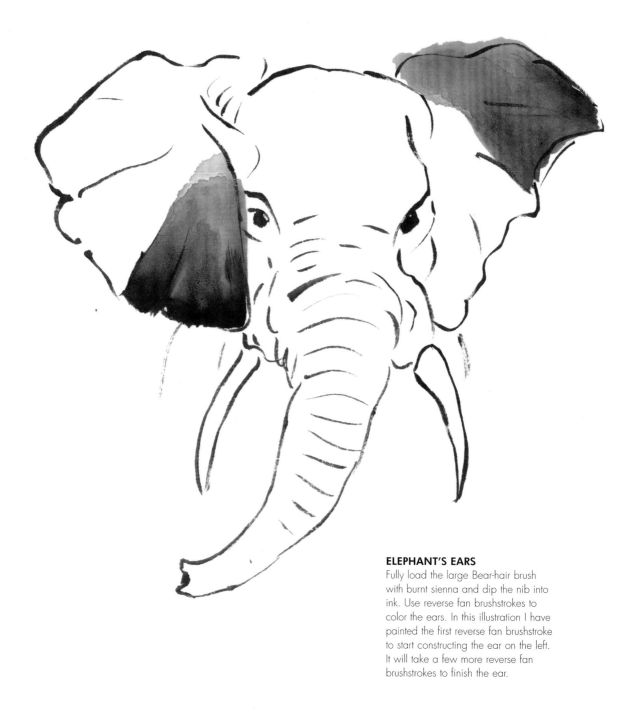

ELEPHANT'S EARS
Fully load the large Bear-hair brush
with burnt sienna and dip the nib into
ink. Use reverse fan brushstrokes to
color the ears. In this illustration I have
painted the first reverse fan brushstroke
to start constructing the ear on the left.
It will take a few more reverse fan
brushstrokes to finish the ear.

PANDA'S EARS
Use multiple fan brushstrokes to paint the ears of a panda with the small Orchid and Bamboo brush.

SHOULDER MUSCLE
A lion's shoulder muscle, created with fan brushstrokes.

WET AND DRY BRUSHWORK

Wet and dry brushwork, used separately or together, produce amazing techniques for painting animals. In both cases, the amount of dryness and wetness is carefully controlled to create a range of varied effects. Different brushes are also used to expand the range, offering you a selection of wet or dry brushwork to suit any animal in this section. I will give you a brief introduction to these forms of brushwork. You will be guided through the more elaborate techniques step-by-step in the next chapter.

WET BRUSHWORK

When you fully load a brush with color and paint on absorbent paper, the resulting brushwork runs. In painting animals, wet brushwork is essential when creating effects of tones and fur.

GRADUAL TONES

If two areas of wet brushwork of different tones of a color are painted closely together so they overlap a little, the two tones will diffuse into each other to create the effect of gradual toning. The same happens if two wet areas of different colors are painted close to each other and overlap a little bit. The toning technique can be extended to more than two tones or colors, but we shall discuss the more complicated techniques for applying tones in the next chapter.

Usually, if you are creating tones in a narrow area, you can use the technique of two-tone loading on the same brush to cover the area. To create tones in a wider area, it is more efficient to use the techniques mentioned in this section.

In the following illustrations, I have used the small Orchid and Bamboo brush to paint strips of color with horizontal side brushstrokes.

Two wet brushstrokes of different tones of burnt sienna, painted so that they overlap slightly

Two wet brushstrokes, one of cadmium orange and the other burnt sienna, painted so that they overlap slightly

Three wet brushstrokes, of three different tones of burnt sienna, overlapping slightly to create gradual toning
The most diluted tone was painted first, with a less diluted tone in the middle, followed by the darkest tone.

Three wet brushstrokes, of three different colors, overlapping slightly

FUR

If you apply brushwork to a wet surface, the brushwork will run, creating a fluffy effect. This is the basic principle for creating soft fur. Here are some of the more popular techniques for creating fur effects.

Thick dark-colored brushwork on a wet surface
If you apply thick, dark-colored brushwork to a wet surface, the dark color will run at the edges to create a fur-like effect. The dark color will not diffuse into the wet background because the color is thick. Effects of this type are especially popular for painting predators' fur.

In this illustration, I used the small Mountain and Horse brush, fully loaded with dark ink that had been left in the open for some time to thicken. I then painted press-and-lift brushstrokes onto a wet surface colored with cadmium orange to create the stripes of a tiger's body.

Softer effect, using wetter colors
For a softer effect, such as the fur of a cat, use wetter colors on a wet surface. The wet colors will diffuse into the wet surface, creating a softer impression. In this illustration, I used ink that had just been poured out of the bottle and had not yet thickened to paint the stripes on a wash of burnt sienna.

Very soft fur, using diluted colors
To paint the soft stripy tail of a lesser panda (see page 159), I used a diluted color to paint the pattern on a wet surface. Diluted colors diffuse more than thick colors, creating a very soft effect.

I prepared burnt sienna and a reddish burnt sienna, made by adding alizarin crimson to burnt sienna. I then diluted both colors. I used the large Bear-hair brush, fully loaded with diluted burnt sienna, to paint the tail with a long side brushstroke. I then added the stripes with the diluted reddish burnt sienna.

DRY BRUSHWORK
The following are the two methods I used to create dry brushwork in this book.

METHOD ONE
When you load a brush with wet paint and wipe off excess moisture on a tissue or a paper towel, the brush becomes a dry brush. The resulting brushwork will have broken dry patches, so we call this dry brushwork. In general painting, this is how you use most brushes to create dry brushwork. However, the hairs of a Mountain and Horse brush do not carry much moisture, as this particular brush is designed to create dry brushwork naturally. With this brush, therefore, all you need to do to prepare it for creating dry brushwork is just to wipe it against the side of the palette to remove the excess moisture.

A dry press-and-lift ink brushstroke with elbow movement, using the small Orchid and Bamboo brush.

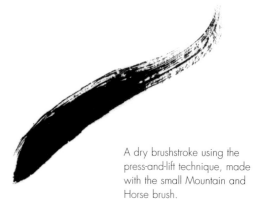

A dry brushstroke using the press-and-lift technique, made with the small Mountain and Horse brush.

METHOD TWO

Here, the brush is dry before painting. Different brushes create different effects with dry brushwork. For example, a wolf-hair brush makes softer brushwork than a horsehair brush, which creates a harder look. A brush with a smaller tip makes narrower brushstrokes. It also makes shorter brushstrokes, because it can only carry a limited amount of color. A large brush, on the other hand, can make longer and wider brushstrokes.

Dry brushwork is popular in animal painting. One of the most common forms of dry brushwork is "broken brushstrokes". Here, the brush is pressed on the palette before or after being loaded with color so that the hairs of the brush tip separate before painting. I will deal with this technique in full detail in the next chapter, where we will elaborate on the use of dry brushwork and develop further techniques. Before we can do this, however, we must first understand the basic principles of dry brushwork.

Dip the tip of a dry small Landscape brush into ink. Press the tip on the palette until the hairs separate. Paint a brushstroke. This brushstroke is soft, short, and narrow.

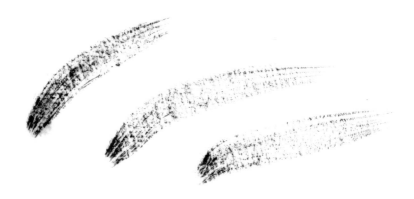

Dip the brush tip of a dry small Mountain and Horse brush into ink. Press the brush tip on the palette until the hairs separate. Paint a brushstroke. This brushstroke is harder, longer, and wider.

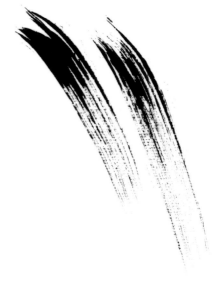

EXERCISES

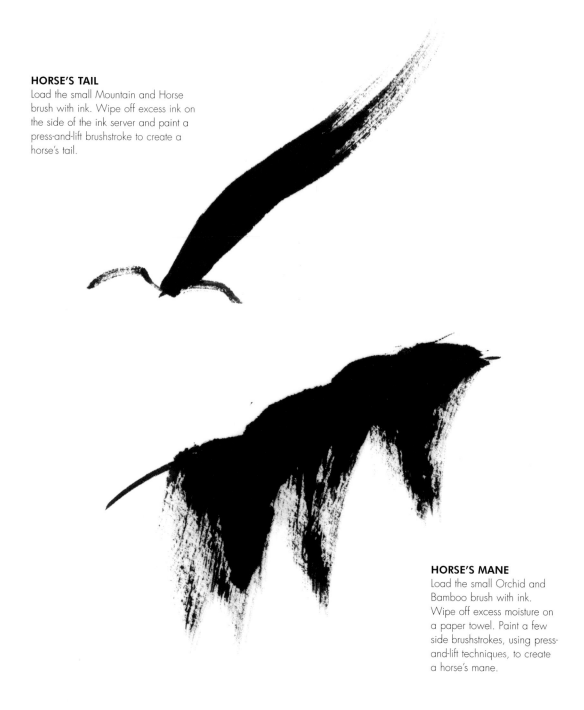

HORSE'S TAIL
Load the small Mountain and Horse brush with ink. Wipe off excess ink on the side of the ink server and paint a press-and-lift brushstroke to create a horse's tail.

HORSE'S MANE
Load the small Orchid and Bamboo brush with ink. Wipe off excess moisture on a paper towel. Paint a few side brushstrokes, using press-and-lift techniques, to create a horse's mane.

SQUIRREL'S TAIL
Dip the tip of a dry, large
Landscape brush into ink.
Press the brush on the
palette until the hairs
separate. Use this dry brush
to draw a squirrel's tail.
Notice how soft such
brushwork can be.

3 PAINTING ANIMALS

It is important to get the shape and proportions right when painting an animal. The outline sketches in the opening section of this chapter are designed to help you practice this before you embark on more complex techniques. Each subsequent section concentrates on a particular style. I will begin each section with instructions that will help you develop the brushstrokes required to paint in that style. It will be worth spending a little time going through the instructions before you tackle painting the animals.

OUTLINE SKETCHES

Sketching enables you to practice getting the shapes of animals right, so the first step for anyone wanting to paint animals is to sketch them. Sketch as often as possible. Make use of real-life animals: your own pets, other people's pets, animals in the zoo, and pictures in magazines and videos, as well as photos you have taken. Simple sketches with flowing brushstrokes are attractive in their own right. You can add colors to your sketches informally, but do not use too much color or you will spoil the simplicity of your artworks. There is no reason why you can't sketch with pencils. I often use pencils for sketching, especially if I am working outdoors. Many people have said that ancient masters did not sketch with pencils, but that is only because pencils had not been invented then! Modern Chinese masters use them a lot. If you are sketching with pencils on Xuan paper, avoid using an eraser too often, because the rubbing will spoil the surface of your paper. Try to sketch with Chinese brushes as well, because you want to be able to draw fluently with these.

HIPPOPOTAMUS
I drew the head of this hippopotamus with the Red Bean brush because I find lines created by the Outline brush too thin for the hippo's tough features.

DORMOUSE
For the dormouse in this illustration, I used wrist movements for shorter lines and elbow movements for the longer ones. I used the Red Bean brush here. You might also try using the Outline brush for the dormouse and the Red Bean brush for the branches. If you are using the Red Bean brush, remember to start with the brush dry and dip only the nib into ink when drawing thin lines. If you do not have much experience with sketching, you may not be happy with your first drawing. Don't give up. Try again. I usually have to try five or six times before I am satisfied with a sketch.

SKETCHES WITH INK

I normally use the Red Bean brush and ink for sketches. Smaller brushes will not carry sufficient ink to sustain a long line. Keep the brush on the dry side. If the brush is wet, it will help to wipe it on a piece of paper towel. Load only the nib of the brush with ink. A fully loaded brush carries too much moisture and the lines you draw will be much thicker. If you want thin lines, hold your brush in a vertical position to draw. Use wrist and elbow movements to make your lines more expressive. You can also use press-and-lift to vary the thickness of the lines. When you are drawing the delicate features of the face, you can use the Outline brush. Use the cushion method for extra support. You can vary the tones of ink to make your sketches more interesting. Sketching is good for practicing wrist and elbow movements. These practice sections will prepare you for the more advanced techniques, in which we shall use both movements a great deal.

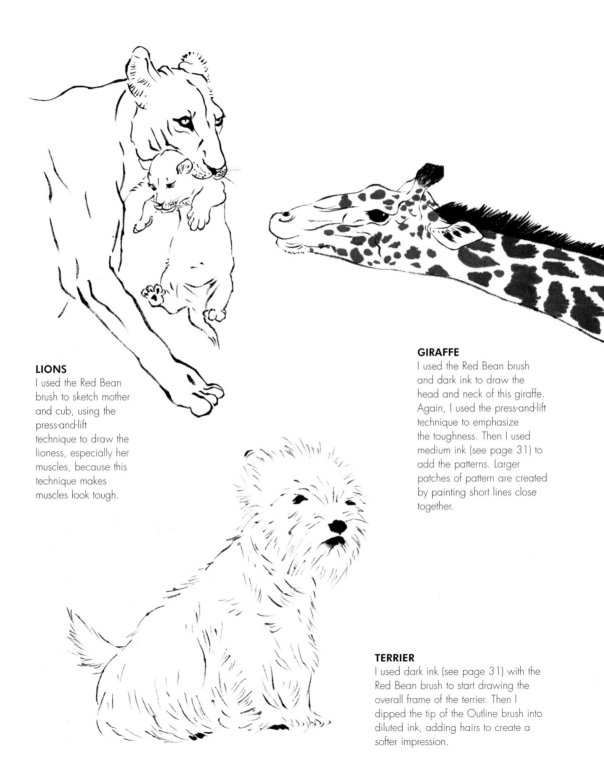

LIONS
I used the Red Bean brush to sketch mother and cub, using the press-and-lift technique to draw the lioness, especially her muscles, because this technique makes muscles look tough.

GIRAFFE
I used the Red Bean brush and dark ink to draw the head and neck of this giraffe. Again, I used the press-and-lift technique to emphasize the toughness. Then I used medium ink (see page 31) to add the patterns. Larger patches of pattern are created by painting short lines close together.

TERRIER
I used dark ink (see page 31) with the Red Bean brush to start drawing the overall frame of the terrier. Then I dipped the tip of the Outline brush into diluted ink, adding hairs to create a softer impression.

SKETCHES WITH INK AND COLOR

If you like, you can add colors informally to your sketches to make them more interesting. You can use the small Orchid and Bamboo brush, the size 3 Leopard and Wolf brush, or the large Bear-hair brush to apply colors, depending on the size of the color patches. Remember that too wet a brush will cause the colors to run beyond the outline of your drawing. Two practices will help you to control the spread of colors. One is always to start with your brush on the dry side. Wipe it on a piece of paper towel to remove excess moisture from the brush before loading colors. The other is to make your colors a bit thicker than usual. I usually use about three parts of water to two parts of color from the tube.

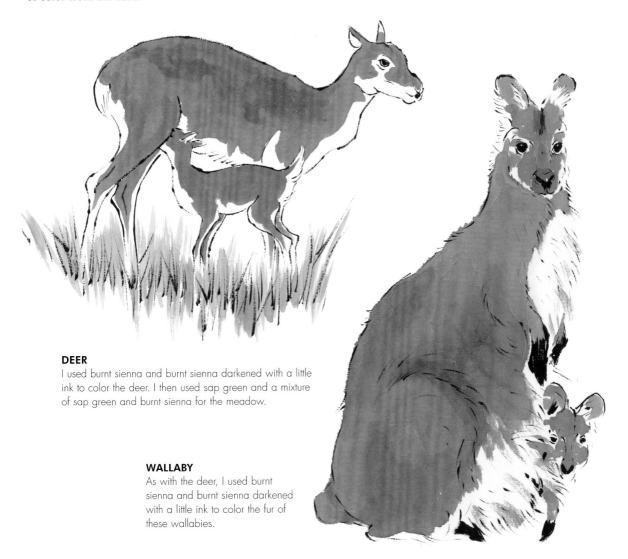

DEER
I used burnt sienna and burnt sienna darkened with a little ink to color the deer. I then used sap green and a mixture of sap green and burnt sienna for the meadow.

WALLABY
As with the deer, I used burnt sienna and burnt sienna darkened with a little ink to color the fur of these wallabies.

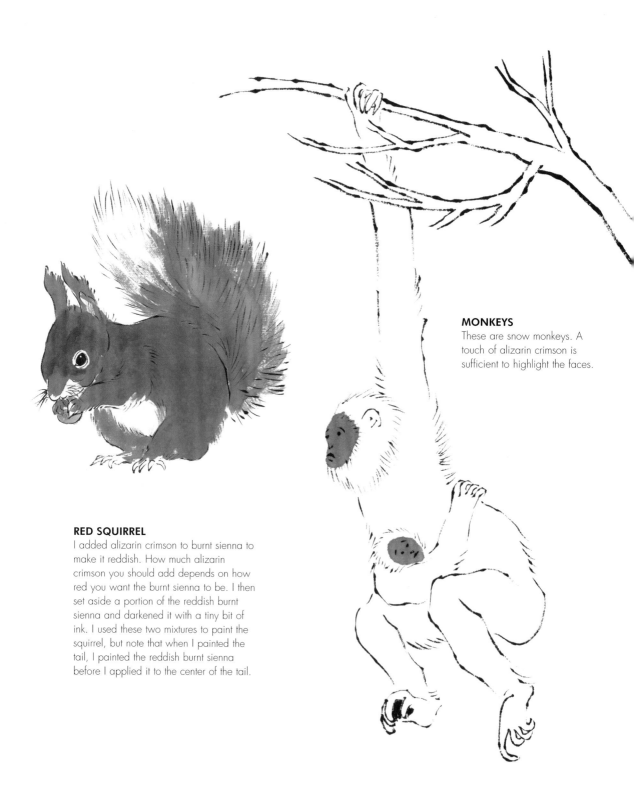

MONKEYS
These are snow monkeys. A touch of alizarin crimson is sufficient to highlight the faces.

RED SQUIRREL
I added alizarin crimson to burnt sienna to make it reddish. How much alizarin crimson you should add depends on how red you want the burnt sienna to be. I then set aside a portion of the reddish burnt sienna and darkened it with a tiny bit of ink. I used these two mixtures to paint the squirrel, but note that when I painted the tail, I painted the reddish burnt sienna before I applied it to the center of the tail.

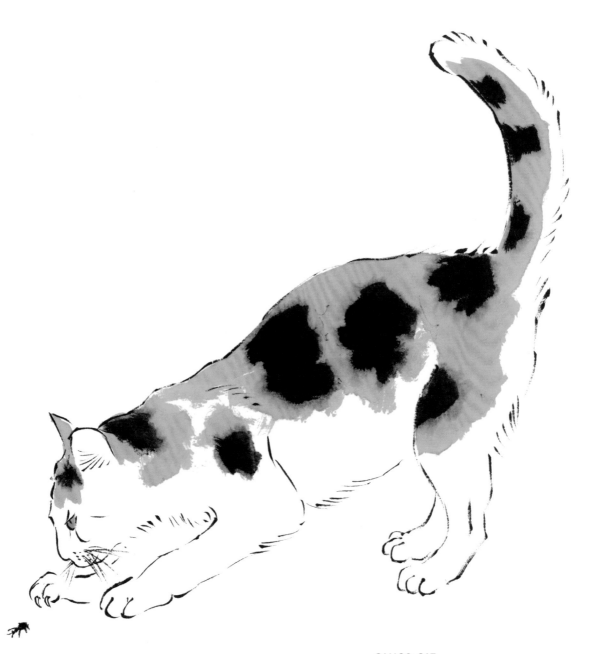

CALICO CAT
This cat has patches of cadmium
orange and ink on her back. I
used gamboge for her eye.

USING BASIC BRUSHSTROKES

Basic brushstrokes are the results of basic techniques: press-and-lift with wrist movement, press-and-lift with elbow movement, side brushstrokes and side brushstrokes with press-and-lift. Every brushstroke has its specific shape. You can combine two or more basic brushstrokes to create complex shapes and build up an image of an animal, and at the same time bring out its character. For example, a long vertical side brushstroke illustrates the straight neck of a horse. A long curved side brushstroke shapes a curved stomach, while you can combine press-and-lift with elbow movement to shape a long leg. The key is to use your brush in a flexible way and be creative: use those brushstrokes that are already available, but when you cannot find any to suit your purpose, create new ones by elaborating on the basic techniques.

Before we begin, let me remind you of some of the more commonly used brushstrokes. At the same time, I shall show you how to extend some of them to form new ones.

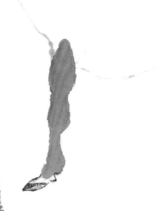

BRUSHSTROKE 1
A basic press-and-lift brushstroke combined with wrist movement is useful for filling spaces. Here, I am using it to paint the ears of a rabbit.

BRUSHSTROKE 2
A long press-and-lift brushstroke using elbow movement is good for painting a long body or tail. A long press-and-lift brushstroke doesn't have to be straight. If you change the direction of the handle of the brush, the long brushstroke will be curved. I am using this brushstroke to paint a horse's tail.

BRUSHSTROKE 3
You can press and lift more than once to produce a long brushstroke with narrow and wide intervals. I am using it to paint a donkey's leg.

BRUSHSTROKE 4
Long dots can be used for filling spaces and for building shapes. Multiple long dots can be used to build up a large brushstroke. Here, I am using multiple long dots to paint a panda's ears.

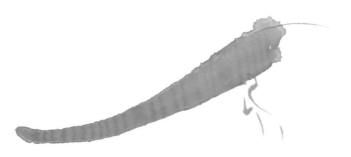

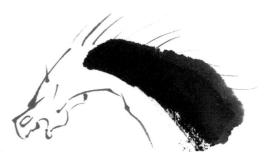

BRUSHSTROKE 5
Extended long dots are very often used to shape tails and legs. Here, I am using an extended long dot to paint a kangaroo's tail.

BRUSHSTROKE 6
Straight side brushstrokes are effective for painting straight features, such as a neck or a leg. Multiple straight side brushstrokes are useful for covering a large area, such as the body of an animal. Here, I am using it to paint a horse's neck.

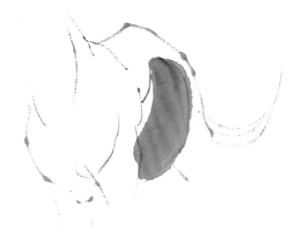

BRUSHSTROKE 8
Long and short curved side brushstrokes are used for filling spaces along a curve. They are also used for creating shoulder muscles. In this illustration, I am using the brushstroke to color a horse's lower abdomen.

BRUSHSTROKE 7
Press-and-lift side brushstrokes, upward or downward, are useful for painting horses' legs.

BRUSHSTROKE 9
Variation 1: Lay the brush on its side with the handle pointing to the right. Move the brush tip to the right and downward and then to the left.

Variation 2: Lay the brush on its side with the handle pointing to the left. Move the brush tip to the left and downward and then to the right.

Variation 3: Lay the brush on its side with the handle pointing to the right. Move the brush to the right and then downward.

Variation 4: Lay the brush on its side with the handle pointing to the left. Move the brush to the left and then downward.

USING SINGLE BRUSHSTROKES

I am starting with a few simple animals. The body of each of these can be created with a single brushstroke. You have to maneuver the brush, using the press-and-lift technique with wrist and elbow movements to create the shape of the body.

COLORS
• Ink
• Burnt sienna
• Chinese white
• Permanent rose

BRUSHES
• Large Bear-hair brush
• Red Bean brush
• Outline brush
• Size 1 Wolf-hair brush for Painting

Rat

The rat is a lucky animal in the Chinese calendar so Chinese artists like to paint them. Many people may not like rats and mice, but painting them is a good way to practice your brushstrokes. Rats are bigger and mice are smaller, but essentially they have the same shape. The body of a rat or a mouse can be created using a single long dot, with either ink or burnt sienna darkened with a tiny bit of dark ink.

STEP 1

Prepare darkened burnt sienna by adding a little bit of ink to burnt sienna. Fully load the large Bear-hair brush. Paint a long dot for the body.

STEP 2

Mix permanent rose with a little bit of burnt sienna. Dip the Red Bean brush into this mixture and add the tail.

STEP 3

Dip the Outline brush into dark ink. Draw the feet and eyes and add details to the body and the tail. Dip the size 1 Wolf-hair brush for Painting into Chinese white and add highlights to the eyes and ears.

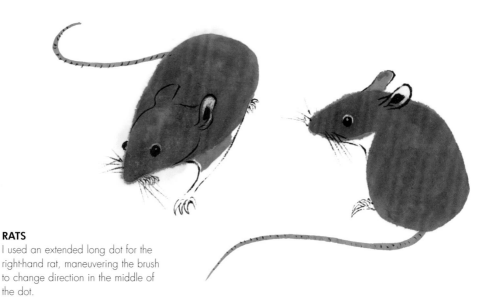

RATS
I used an extended long dot for the right-hand rat, maneuvering the brush to change direction in the middle of the dot.

Lizard

You can create the body of a lizard with one single brushstroke, using the press-and-lift technique.

STEP 1

Load the small Orchid and Bamboo brush with burnt sienna. Use a single brushstroke to paint the body. You can start from the head or the tail (I started from the head). Press to widen the brushstroke to paint the body, and then gradually lift the brush to finish with the tail. Change the direction of the brushstroke according to the movement of the body (refer to the brushstrokes on page 84). If you start painting from the tail, hold your brush at an angle to the paper with only the nib of the brush touching the paper. Slowly press the brush as you paint the tail, then the body, finally lifting a little to form the head. Always adjust the handle of the brush to point in the direction of your brushstroke movement.

STEP 2

When the color is dry, add the legs with burnt sienna. Draw the body pattern, using the Red Bean brush loaded with ink and Chinese white.

COLORS
• Ink
• Burnt sienna
• Chinese white

BRUSHES
• Small Orchid and Bamboo brush
• Red Bean brush

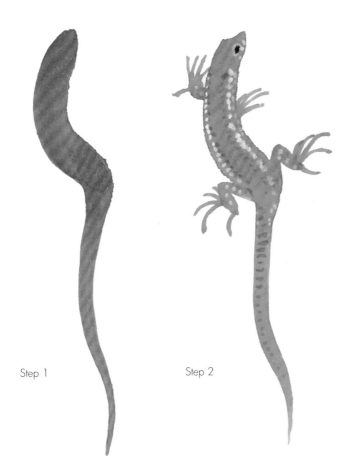

Step 1 Step 2

Snake

COLORS
• Ink
• Sap green
• Chinese white
• Cadmium red

BRUSHES
• Large Bear-hair
 brush
• Small Orchid and
 Bamboo brush
• Red Bean brush
• Size 1 Wolf-hair
 brush for Painting

Use a large brush, because this will hold a lot of paint, which means you can go a longer way. Snakes have long, twisting bodies. If you use the small Orchid and Bamboo brush, you may have to reload the brush with color halfway through painting and you may lose the momentum you need to maintain the correct width of the body. The body is thinner in the part near to the head, but bigger in the middle; it then thins down toward the tail. Press the brush to widen the brushstroke and lift it to make it thinner. To achieve uniform thickness in the middle of the body, it is important to maintain a constant pressure on the brush.

STEP 1

Load the large Bear-hair brush with sap green. Paint the long body, using elbow movement and starting with the head. Press when the body is wider and lift when it thins down, finally lifting the brush to finish with the tail (refer to brushstroke 2 on page 84). Always adjust the handle of the brush to point in the direction of your brushstroke.

STEP 2

Use the small Orchid and Bamboo brush and sap green to add a long dot to each side of the head, creating a triangular shape.

STEP 3

When the color is dry, dip the size 1 Wolf-hair brush for Painting into cadmium red and paint the tongue. Next, dip the brush into dark ink and draw the scales. Add the eyes and the rest of the pattern with the Red Bean brush, using ink, Chinese white and cadmium red.

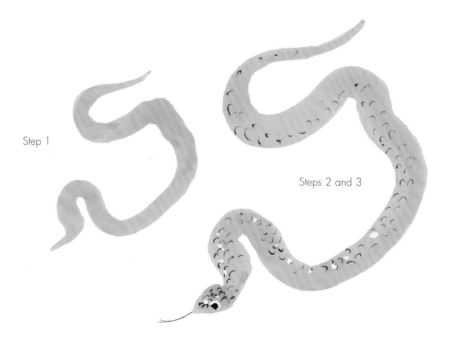

Step 1

Steps 2 and 3

USING LARGE BRUSHSTROKES

Basically, a large brushstroke is a large patch of color, usually painted using a large brush. If you are using a smaller brush, you have to use multiple brushstrokes to build it up, using long dots or short press-and-lift brushstrokes, or a mixture of both. For a very large patch of color, side brushstrokes are best for filling up spaces and even if you use a large brush, you may still need to make multiple brushstrokes when painting some animals.

Panda

The panda is a symbol of China. A few brushstrokes with ink in a lively style expresses a panda's shape, movement, character, and mood. A panda is made up of large patches of black and white, so you can use ink to paint the black patches with a large brush. To create the white patches, you can leave the spaces blank on the paper.

STEP 1
Use the Red Bean brush and diluted ink to sketch a panda. Carefully mark the dark patches.

STEP 2
Use either the small Orchid and Bamboo brush or the large Bear-hair brush to paint the dark patches with dark ink (see page 31). You can use long dots, side brushstrokes, or a mixture of both. To convey the texture of fur, start at the edge of a patch that you want to fill with color. Use a smaller brush to paint the fur effect along the edge with small press-and-lift brushstrokes and then fill the rest of the patch with color. The illustration on the right shows how to start the press-and-lift brushstrokes on a panda's leg to create a fur effect.

STEP 3
Dip the Red Bean brush into dark ink and draw the outlines to finish. You can add some claws to the paws and also the pupils of the eyes, using Chinese white and the size 1 Wolf-hair brush for Painting. Each paw of a panda has six digits, but you seldom see all of them. Usually you can't see the eyes or the digits, because they are black, so you only see an outline of them when they catch the reflection of light.

COLORS
- Ink
- Chinese white

BRUSHES
- Red Bean brush
- Small Orchid and Bamboo brush or large Bear-hair brush
- Size 1 Wolf-hair brush for Painting

Step 1

Steps 2 and 3

MORE ANIMALS PAINTED WITH LARGE BRUSHSTROKES

You can also paint a panda on a piece of absorbent paper tinted with a color wash. Proceed with the same steps as before. When all the ink brushwork is dry, use Chinese white to fill the white parts of the panda's body.

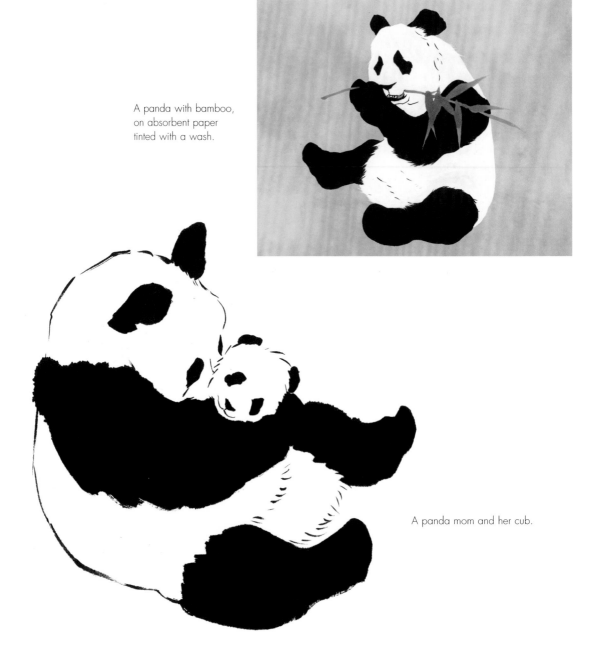

A panda with bamboo, on absorbent paper tinted with a wash.

A panda mom and her cub.

DUTCH RABBIT
You can use the panda-painting techniques to paint a Dutch rabbit. Use diluted permanent rose to tint the ears, nose, mouth, and feet.

BLACK CAT
If you want to paint a black cat without toning, use multiple brushstrokes to build up the black body of the cat, adding in the details of the face, teeth, paws, and whiskers.

USING MULTIPLE BRUSHSTROKES

Animals with more complex shapes can be painted with multiple brushstrokes, using different strokes for different parts of the body. Multiple brushstrokes are very popular with animal painters – they create a more three-dimensional figure. Theoretically, any animal can be painted with the Chinese brush using multiple brushstrokes. In this section, I will show just a few examples, but I hope you will feel free to use the same techniques to paint animals other than those illustrated.

KANGAROO

COLORS
- Ink
- Darkened burnt sienna, made by adding a tiny bit of ink to burnt sienna

BRUSHES
- Red Bean brush
- Size 3 Leopard and Wolf brush
- Small Orchid and Bamboo brush
- Small Mountain and Horse brush
- Large Bear-hair brush
- Outline brush

I have used only one tone of burnt sienna to paint the kangaroo, but I have an effective and unique way of applying the tones that is easy to carry out.

The top diagram on the opposite page numbers all the brushstrokes used for painting the kangaroo. Each number corresponds to the number of a brushstroke from the list on pages 84–85. It is only a suggestion, but I hope that this will help you to start building shapes.

Use the size 3 Leopard and Wolf brush to paint the brushstrokes for the head. Use the small Orchid and Bamboo brush, the small Mountain and Horse brush, and the large Bear-hair brush for the body, selecting your brush according to the size of each brushstroke. Leave a little space between adjacent brushstrokes.

STEP 1
Sketch the outline of a kangaroo with the Red Bean brush and diluted ink (see page 31), following the outline in the diagram. Prepare burnt sienna, darkened with a little bit of ink.

STEP 2
Start by constructing the face and the head, following the bruhstrokes shown in the diagram. Next, use a large brush to paint the tail with an extended long dot. Continue to sweep the extended long dot to form the back. Alternatively, use a separate side brushstroke to paint the back.

STEP 3
Follow the brushstroke diagram to finish adding all the other brushstrokes. Remember to leave a narrow gap between two adjacent brushstrokes.

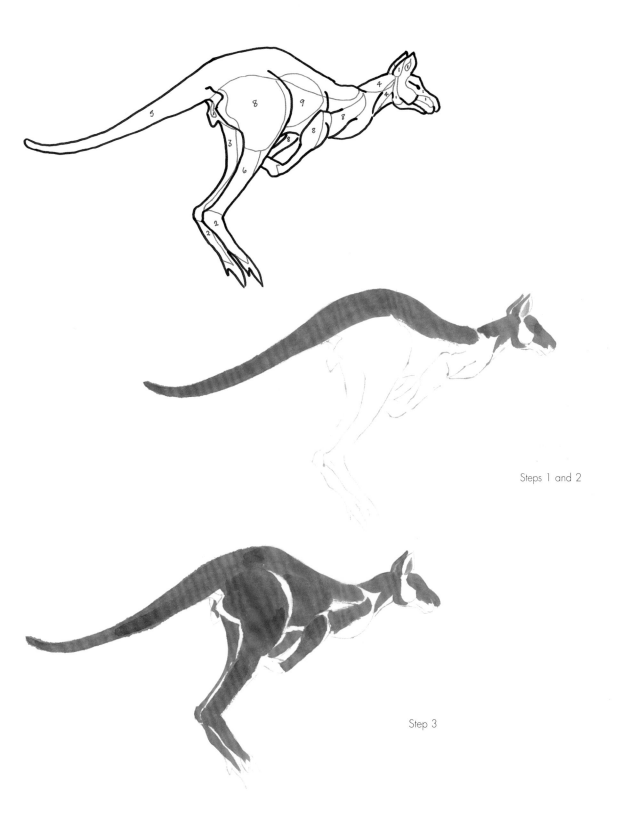

Steps 1 and 2

Step 3

STEP 4

While the color is still wet, use a clean size 3 Leopard and Wolf brush to apply clean
water to the spaces between brushstrokes, also touching the sides of each brushstroke.
The purpose is to soften the edges of the color and create tones to link muscles together.
Leave the color to dry.

STEP 5

Use the Outline brush and dark ink to add features to the face and to the feet, and then
use the Red Bean brush to add outlines wherever these will enhance the general effect. I
used dark ink for some outlines and the darkened burnt sienna for others.

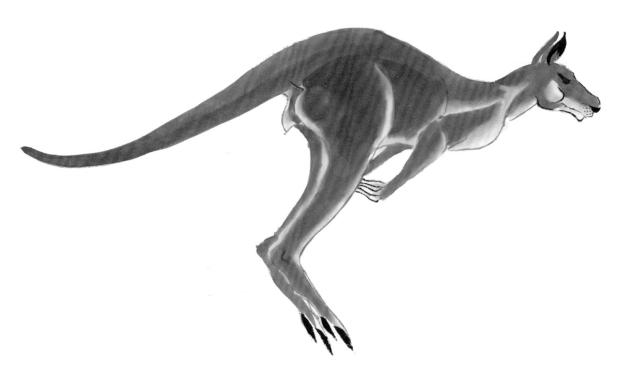

Steps 4 and 5

MORE ANIMALS PAINTED USING MULTIPLE BRUSHSTROKES

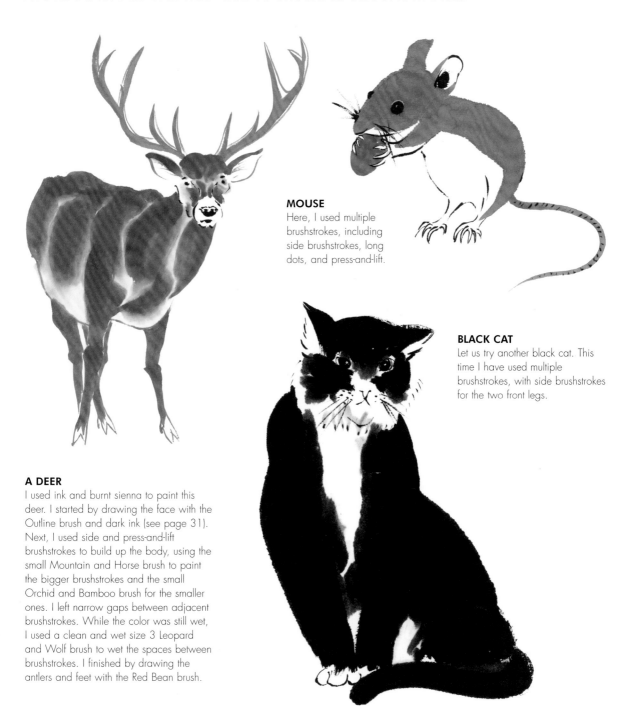

MOUSE
Here, I used multiple brushstrokes, including side brushstrokes, long dots, and press-and-lift.

BLACK CAT
Let us try another black cat. This time I have used multiple brushstrokes, with side brushstrokes for the two front legs.

A DEER
I used ink and burnt sienna to paint this deer. I started by drawing the face with the Outline brush and dark ink (see page 31). Next, I used side and press-and-lift brushstrokes to build up the body, using the small Mountain and Horse brush to paint the bigger brushstrokes and the small Orchid and Bamboo brush for the smaller ones. I left narrow gaps between adjacent brushstrokes. While the color was still wet, I used a clean and wet size 3 Leopard and Wolf brush to wet the spaces between brushstrokes. I finished by drawing the antlers and feet with the Red Bean brush.

EXPRESSIVE BRUSHSTROKES

I am sure many readers are impressed by the expressive way in which artists can depict an entire animal in only a few brushstrokes. The way masters do this appears almost magical, but with practice, you can accomplish this technique. The key to achieving this style of painting is to use brushstrokes well. I will demonstrate this beautiful technique with a painting of a cat. We know that we can paint the cat with many basic brushstrokes, however, when you know your brushstrokes really well, you can link brushstrokes together and deliver one continuous stroke without having to lift the brush off the paper. We usually use a large brush for this technique, because it can carry more color and therefore it goes a longer way. A large brush also enables you to achieve a greater range of widths by pressing, lifting, and using the brush on its side.

CAT PAINTED WITH BASIC BRUSHSTROKES

The outline is indicated by the diluted ink. I used different brushstrokes to paint the head and side brushstrokes, close together, to paint the body. In the illustration, I left narrow gaps between brushstrokes to show you the position of each. In a normal painting, you would pack the brushstrokes close together to form larger ones.

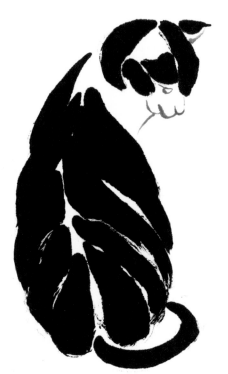

Painting a cat in the usual way, with basic brushstrokes.

Step 1

CAT PAINTED WITH EXPRESSIVE BRUSHSTROKES

Now I am going to link brushstrokes together and paint the cat
again. It is more convenient to use a large brush to paint a long
continuous brushstroke, so I used a large Bear-hair brush, fully
loaded with dark ink (see page 31). The whole body was executed in
three expressive brushstrokes. The key to linking brushstrokes
together to form a continuous one, complete with all the different
widths, is to constantly press or lift, changing the angle of the brush
to the painting surface, and changing the direction of the brush
handle to follow the shape of the body. There is a lot happening in
one continuous brushstroke, so you have to be familiar with the
shape you are aiming at and be efficient in maneuvering the brush to
construct the shape. It is hard work, but the result is very rewarding.

Step 2

STEP 1

I started the brushstroke at the forehead with a fully loaded large
Bear-hair brush. I moved the brush to the top of the head and down
to the neck, leaving a space in between to shape the ear. You should
press and lift the brush to acquire the necessary width at different
places. If you find the large Bear-hair brush too large to handle, you
can use the small Mountain and Horse brush for this brushstroke.

STEP 2

Fully load the large Bear-hair brush, again with dark ink. Start with
the brush in a vertical position at the neck of the cat. As you move
the brush downward, press and at the same time gradually lower the
angle of the brush until you are using the side of the brush to finish
the brushstroke.

Step 3

STEP 3

Use the same technique as used for the second brushstroke to paint
the third stroke, completing the other half of the body. As you reach
the bottom part of the body, gradually increase the angle of the
brush until the brush is in a vertical position. Press to continue and
paint the tail. I added a small press-and-lift brushstroke to paint the
other ear and a long dot for the cheek. Then I used the Outline
brush to add final details.

MORE ANIMALS PAINTED USING EXPRESSIVE BRUSHSTROKES

CAT
A cat is the perfect subject for practicing this technique. Note how the whole body was constructed in one brushstroke. I started with the tail, using medium ink (see page 31). Where the tail joins the body, I lowered the angle of the brush and used side brushstrokes to complete the body. Then I added a dot of dark ink at the tip of the tail.

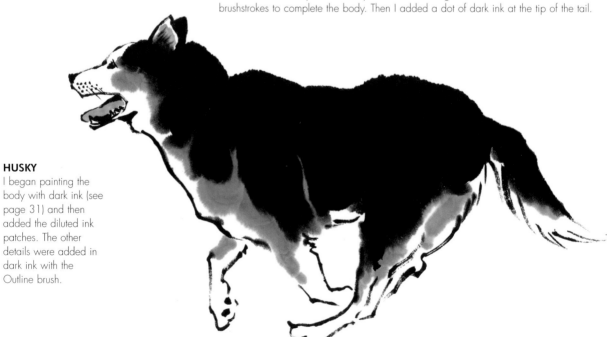

HUSKY
I began painting the body with dark ink (see page 31) and then added the diluted ink patches. The other details were added in dark ink with the Outline brush.

WEASEL

Using a large brush, I started by painting the head, maneuvering the brush using press-and-lift, wrist and elbow movements and side brushstrokes, and then continued on to paint the neck. I lowered the angle of the brush and used side brushstrokes to construct the body, using the same technique to continue on for the thigh of the hind leg. At this point I rotated my wrist to position the brush at a high angle to finish the lower part of the leg, all as part of the same movement. If you find this too ambitious to complete in one go, you can always use different brushstrokes to construct the body. I used the same brush and color to add the front leg and tail, and then added the other details with the Red Bean brush and ink.

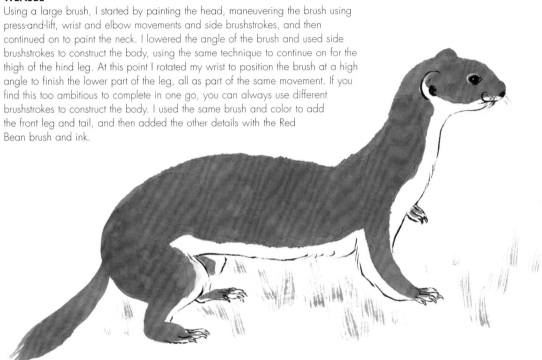

OTTER

I used two brushstrokes to construct the body, using burnt sienna darkened with a little bit of ink. One brushstroke started from the head and the other started from the narrow end of the tail. As each of the brushstrokes lengthened, I gradually lowered the angle of the brush until it was on its side to cover the width of the body.

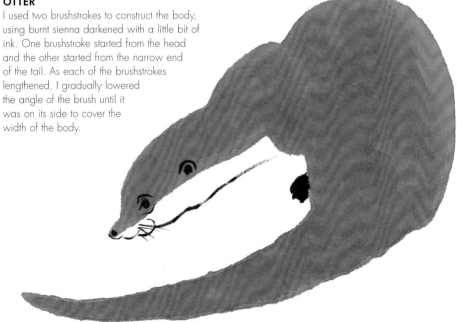

TWO-TONE AND TWO-COLOR LOADING

To paint smaller-scale animal artworks with different tones or colors, it is more convenient to use two-tone or two-color loading. I will demonstrate painting a monkey with these techniques, using multiple brushstrokes. Monkeys are fun to paint; they have long arms and legs, so you can paint them with side brushstrokes, using elbow movements. Hold the brush at different angles to the paper to control the width of a side brushstroke. If a stroke needs to be very wide, use two or three brushstrokes to build up the width.

MONKEY

COLORS
• Ink
• Burnt sienna
• Alizarin crimson

BRUSHES
• Red Bean brush
• Outline brush
• Small Mountain
　and Horse brush

STEP 1
Draw a sketch of the monkey with the Red Bean brush and diluted ink (see page 31). Draw the face with the Outline brush and dark ink (see page 31).

STEP 2
Prepare burnt sienna and burnt sienna darkened with a little bit of ink. Load the small Mountain and Horse brush with burnt sienna and dip the nib of the brush into dark ink. Paint the hair of the head, using press-and-lift brushstrokes.

STEP 3
Fully load the small Mountain and Horse brush with the darkened burnt sienna and paint two straight side brushstrokes to form the front-left arm. While the color is still wet, dip the Red Bean brush into dark ink and add the fingers. Use multiple side brushstrokes to paint the body. Then add the other arm and two legs. Fully load the small Mountain and Horse brush, again with the darkened burnt sienna, and dip the nib of the brush into dark ink. Holding the brush vertically, paint the tail from the tip until it finally joins the body. As you paint the long tail, the dark ink will slowly run out, leaving the brush with the darkened burnt sienna to join the body, which has the same color. Use the Red Bean brush and diluted alizarin crimson to color the face and the inside of the ear.

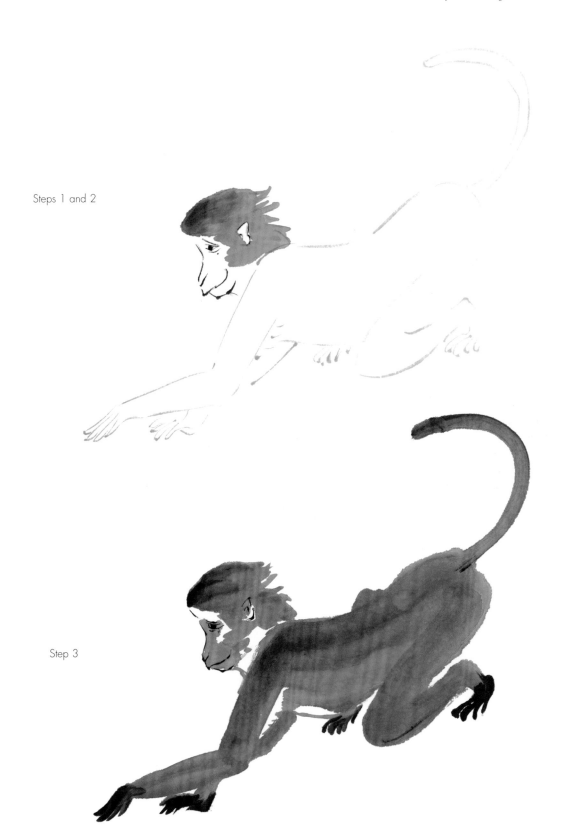

Steps 1 and 2

Step 3

MORE ANIMALS PAINTED USING TWO-TONE
AND TWO-COLOR LOADING

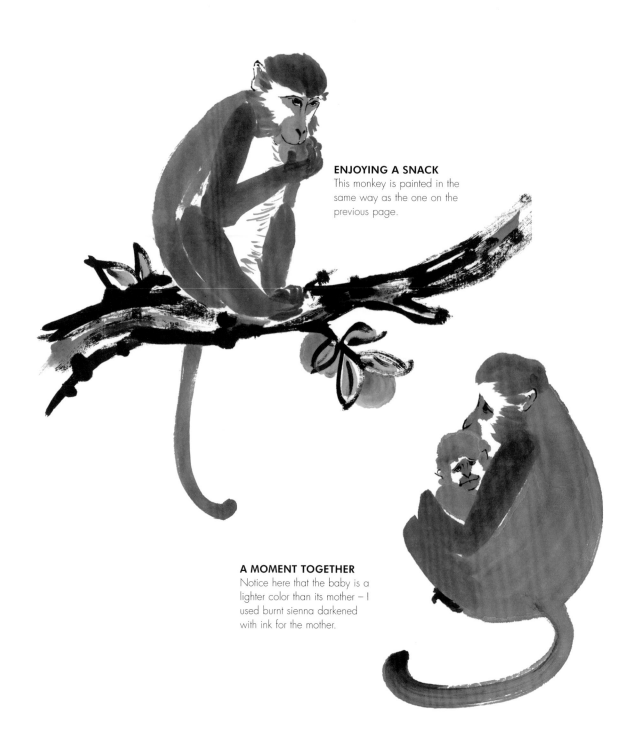

ENJOYING A SNACK
This monkey is painted in the
same way as the one on the
previous page.

A MOMENT TOGETHER
Notice here that the baby is a
lighter color than its mother – I
used burnt sienna darkened
with ink for the mother.

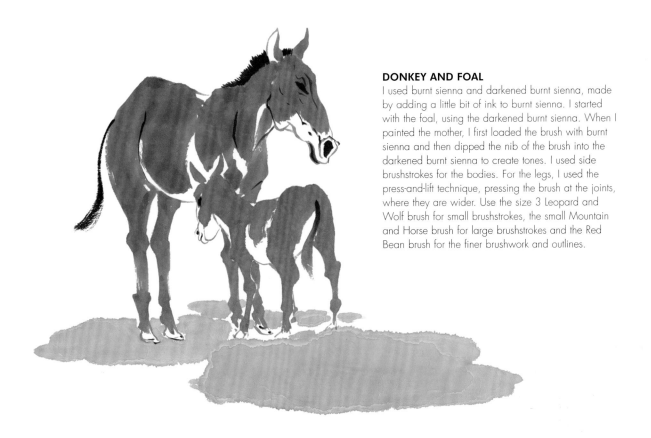

DONKEY AND FOAL

I used burnt sienna and darkened burnt sienna, made by adding a little bit of ink to burnt sienna. I started with the foal, using the darkened burnt sienna. When I painted the mother, I first loaded the brush with burnt sienna and then dipped the nib of the brush into the darkened burnt sienna to create tones. I used side brushstrokes for the bodies. For the legs, I used the press-and-lift technique, pressing the brush at the joints, where they are wider. Use the size 3 Leopard and Wolf brush for small brushstrokes, the small Mountain and Horse brush for large brushstrokes and the Red Bean brush for the finer brushwork and outlines.

RELAXING TOGETHER

After a hard day ploughing the fields, this Southeast Asian water buffalo enjoys a relaxing and well-earned bath in the river. Here, the young boy in charge of the buffalo is taking a nap on his friend's back. For the colors of the buffalo I prepared burnt sienna and burnt sienna darkened with a little ink. I used two-color loading to paint the head and body.

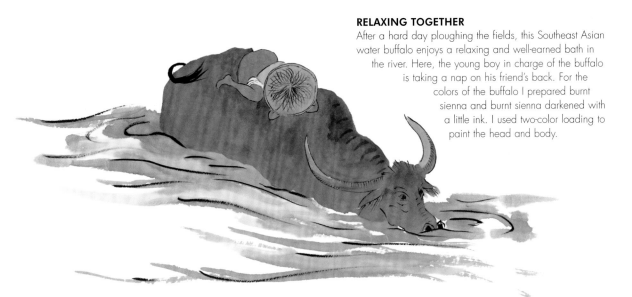

COLORS
- Ink
- Burnt sienna
- Sap green

BRUSHES
- Large Bear-hair brush or extra-large Mountain and Horse brush
- Red Bean brush
- Outline brush

PROJECT: CAMELS

The camel is a very popular subject for painting with expressive brushstrokes. The process is easy and fun, and you only need one large brush. I have painted these camels with two humps because dromedaries are of Asian origin.

I used three colors to paint each camel. For the camel lying down I used burnt sienna, burnt sienna darkened with a little ink, and dark ink (see page 31). For the standing camel I used the same darkened burnt sienna, an even darker mix made by adding even more ink to burnt sienna, and dark ink. The darker colors used for the standing camel help to make it look slightly further away. Prepare all the mixes before you begin to paint because you will need to apply successive colors while the first colors are still wet, and you will not have time to mix up fresh colors while you paint.

STEP 1

Begin with the camel lying down. Fully load a large brush with burnt sienna. Start with the face and continue to paint the neck, pressing the brush if you need to widen the stroke. Without stopping, lower the angle of the brush and use a side brushstroke to paint the upper part of the body, then continue on to finish the camel's hindquarters. Without hesitating, raise the angle of the brush until it is higher and paint in the hind legs. Use the same brush and color to add the front leg. Now dip the brush into darkened burnt sienna and paint the lower abdomen, using side brushstrokes. Use the same color to add long dots for the feet. Clean the brush and fully load it with dark ink. Add the lumps of hair on top of the humps, at the back and front of the neck, on top of the head, and across the top of the front leg. Allow all the colors to dry before using the Outline brush to add the tail and features of the face with dark ink.

STEP 2

Use the same techniques to paint the standing camel, but this time start with the lighter darkened burnt sienna, followed by the darker darkened burnt sienna. This camel also has two hind legs to finish.

STEP 3

Prepare three colors: dark ink, sap green, and a mixture of one part sap green to one part burnt sienna. Use these to paint in the grass with the Red Bean brush.

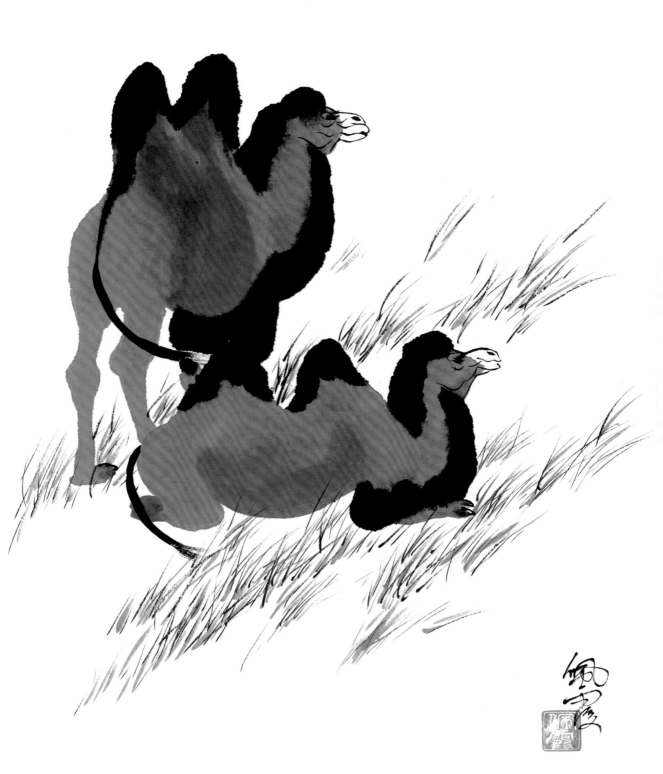

USING TONAL TECHNIQUES

Toning is an essential technique in animal painting. Whether you are painting with ink or with watercolors, tonal techniques can be used to create three-dimensional effects and bring animals to life. You can create tonal effects with two or more shades of a single color or with two or more colors. The following are a few tips for creating successful toning.

TIPS FOR USING TONAL TECHNIQUES

1. First, make sure your brush is fairly dry before loading it with color. If you use a wet brush, you will upset the delicate balance of the intended tone because the extra moisture in the brush will dilute the color. Also, the extra moisture will cause the brushwork to expand more than you had planned. So before you load the brush with ink or a color, wipe it on absorbent paper, such as a paper towel, to get rid of as much moisture as possible.

 It is worth mentioning that most Chinese brush artists paint very large paintings. When you paint animals on this scale, using the non-outline style on absorbent paper, you need a lot of moisture. Wet brushes seldom cause colors to bleed beyond the intended outline when you are painting on a large scale. However, when you are painting small-scale animals, any excessive moisture will expand a lot. If you make sure your brush is fairly dry before loading it, you will minimize the likelihood of this unwanted expansion.

2. You may find that it is more convenient to use different brush sizes to apply the tones in different areas. For example, use the Red Bean brush for the small parts on the face and the size 3 Leopard and Wolf brush for the legs and arms. For the body, use the small Orchid and Bamboo brush or small Mountain and Horse brush. For even larger areas, such as the back of a pig or an elephant, you can use the extra-large Mountain and Horse brush or the large Bear-hair brush.

3. Consider the order in which you work. I like to contrast detailed dry brushwork with the looser, expressive tonal areas. You can paint the details and then the tones or vice versa, provided that one type of brushwork is dry before you apply the other. The advantage of painting the details first is that these dry quickly and you can then get on with the broader tonal areas. If you start with the wet tones, you will have to wait longer for your work to dry before you can add in the details. However, the advantage of painting in the broader tones first is that if the paint spreads further than you had intended, you can adjust the boundaries of the details to hide this.

TONAL METHODS

There are many tonal techniques, but the following three methods are the most popular. You can use any of these for painting any animal, or you can combine two or more methods when painting a single animal.

Method 1: Applying clean water first

The simplest way to create two tones is to wet the edge of the area where you are going to apply color with clean water. You then add color to the rest of the area, overlapping a little of the clean-water area. The color will run into the clean water to create gradual tones. When you apply the clean water or color, do not apply it right to the edge of the intended area. Leave a narrow gap of dry paper between the outline of the area and the application of the water or color, as the latter will eventually expand. Leaving a dry gap will prevent the wetness expanding too far beyond the intended edges.

STEP 1
The two lines at the top and bottom show the area where you are going to apply color.
I applied clean water to the lower half of the area, leaving a narrow dry gap near to the lower edge. The dark lines indicate the area where water was applied.

Step 1

STEP 2
Apply color (I used burnt sienna here) to the upper half, overlapping the clean-water area a little. Again, leave a narrow dry gap between the upper edge and the color. You can see how the color expands.

The size of the clean-water patch affects the outcome of the toning: if you apply a thin line of clean water, the toning will only extend thinly, but it will extend to a wider area if you apply a wide water patch. You have to control the clean water patch. For example, in painting animals, make the clean-water patch wider in the abdomen area, but limit it to a thin line when painting the face or limbs.

Step 2

Adding tones to the abdomen area of an animal.

Adding tones to an animal's leg.

Method 2: Applying different tones separately

You can use this method to apply two or more tones of the same color. Begin with one tone and then apply another tone of the same color, applying it next to the first one and overlapping the two a little bit. You can go on adding more subtly graded tones next to each other. The easiest way is to start with the most diluted tone and add the next most diluted one. This way, you do not need to rinse your brush. If you were to start with the darkest tone, you would have to rinse your brush clean in order to follow on with a more diluted tone. This is the most popular toning method, because it is so flexible: you can use as many tones or as many colors as you like, and you can cover a large area with this technique. The steps below also apply to multi-colored toning.

Here, I used three tones of burnt sienna and the small Orchid and Bamboo brush, painting long straight side brushstrokes with each tone.

STEP 1
Start by applying the most diluted tone.

STEP 2
Add the next most diluted tone above it, overlapping a little of the most diluted tone.

STEP 3
Add the darkest tone above the other two, again overlapping a little bit of the previous tone.

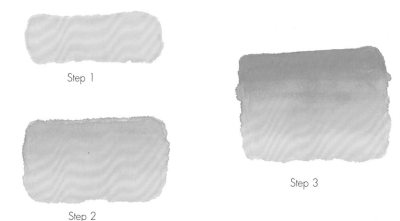

Step 1

Step 2

Step 3

Variation

If you want a darker tone to be stronger, you need to apply the darker tone before the more diluted one. For example, if you were painting a black horse in different tones of ink, you might want the dark ink to be more distinctive, to express the toughness of the muscles. In this case, the darker tone will be applied first, to indicate the position of the muscles. The dark tone will sink into the absorbent paper before the more diluted tone is added and will stand out, creating a strong feature.

In this illustration, I used this technique to paint the shoulder muscle of a horse. I started with the small Mountain and Horse brush and used dark ink (see page 31) to paint a curved side brushstroke. Then I cleaned the brush and dipped it into diluted ink to apply short side brushstrokes, overlapping the dark ink.

Shoulder muscle of a horse.

MULTI-COLORED TONING

Method 2 also works for multi-colored toning. Again, the usual practice is to apply the lightest color first, followed by the second lightest color and so on.

In this illustration, I used cadmium orange, followed by burnt sienna, finishing with burnt sienna darkened with a little bit of ink.

Method 3: Two-tone or two-color loading

Load a brush with two tones of the same color, with the darker tone at the nib of the brush. Any resulting brushwork will carry two tones of the color, the darker tone appearing where the nib of the brush touches the paper. The same principle applies to two-color loading on a brush. This is an efficient way of applying two tones or colors at the same time. For three-color toning, it is better to use method 2.

A side brushstroke, using a brush loaded with two tones of the same color
I loaded the brush with diluted burnt sienna and dipped the nib into burnt sienna. I then painted a horizontal side brushstroke.

A side brushstroke, using a brush loaded with two colors
I loaded the brush with burnt sienna and dipped the nib into ink. I then painted a horizontal side brushstroke.

COVERING A LARGE AREA WITH TWO-TONE OR TWO-COLOR LOADING

Your brush may not be large enough to cover the whole of a large area. In this case, you can use two-tone or two-color loading to cover part of the area, and then extend the colors on each side of the brushstroke. This illustration will give you a clearer idea how this works.

Here, I loaded the small Orchid and Bamboo brush with burnt sienna and dipped the nib of the brush into ink. I placed the nib next to the edge and painted a curved side brushstroke. Then I cleaned the brush and loaded it with burnt sienna to finish coloring the area.

COMBINING METHODS

Each of the above three methods can be used on its own, but we very often use more than one method in a single painting, so I am going to show you how easy it is to combine methods.

COMBINING METHODS 1 AND 2
Start with a long side brushstroke, made with clean water. Add a long side brushstroke above the clean-water area, using cadmium orange, and then make another long side brushstroke, this time using burnt sienna. Overlap adjacent brushstrokes.

COMBINING METHODS 1 AND 3
Start with a long side brushstroke, made with clean water. Fully load a brush with burnt sienna and dip the nib of the brush into ink. Paint a long side brushstroke above the clean-water area, overlapping it a little bit.

COMBINING METHODS 2 AND 3
Start with a long side brushstroke of diluted burnt sienna. Fully load the brush with burnt sienna, and dip the nib of the brush into ink. Paint a long side brushstroke above the diluted burnt sienna, overlapping it a little bit.

COLORS
• Ink
• Permanent rose

BRUSHES
• Red Bean brush
• Small Orchid and Bamboo brush
• Small Mountain and Horse brush
• Extra-large Mountain and Horse brush or large Bear-hair brush

Pigs

A pig's body is smooth and does not have many visible muscles. The most effective way to paint a pig is to use a gradual toning of ink. I built up the different tonal areas one by one, using Methods 1 and 2, starting with clean water and then the most diluted tone. When all the ink tones had been applied and had dried, I used diluted permanent rose to highlight the nose, the ears, the mouth, and the ankles.

STEP 1

Draw the outline of a pig with the Red Bean brush and diluted ink, and then make three tones of ink: diluted, medium, and dark (see page 31).

STEP 2

Lightly load the small Orchid and Bamboo brush with clean water and wet the area where you want to have lighter color (or leave it blank). Fully load the small Mountain and Horse brush with diluted ink and paint the part next to the clean water with side brushstrokes.

STEP 3

Load the small Mountain and Horse brush with medium ink and continue to add color to the pig's body.

STEP 4

Fully load the large Bear-hair brush with dark ink. Place the nib of the brush along the upper edge, with the neck of the brush touching the medium ink. Go across with a long side brushstroke, following the outline of the body. Alternatively, you can use the small Mountain and Horse brush and paint two or three long side brushstrokes. Leave all inked areas to dry. Next, dip the Red Bean brush into dark ink and draw the eyes, nose, the feet, tail, and any outlines you want to add. Use diluted permanent rose to add color to the nose, ears, mouth, and ankles.

Step 1

Step 2

Step 3

Step 4

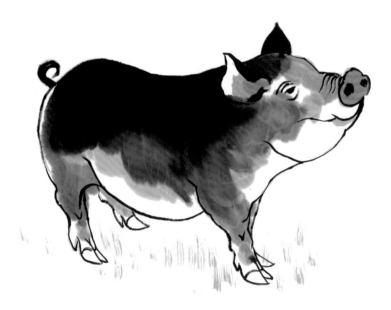

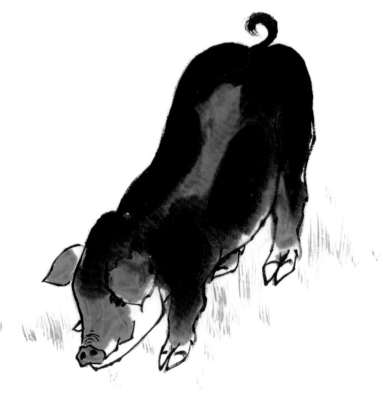

For this illustration, I started with the most diluted ink in the center of the pig's back. I then moved outward, adding darker tones of ink.

COLORS
• Ink

BRUSHES
• Red Bean brush
• Small Mountain and Horse brush

Horses

When it comes to painting horses, many artists favor a completely tonal, non-outline approach. I personally like to use outlines for the head and legs, as this makes them more clearly defined and sharp. Horses are the ultimate test of your ability to express the shape, movement, and character of an animal. In the following demonstrations I am going to show you how to paint horses in two different ways: one with ink and the other with color.

PAINTING A HORSE USING INK

In order to define a horse's muscles, we use method 2 (pages 108–109) but we start filling in the tonal areas with dark ink (see page 31) so that they stand out more clearly. Here, I am going to show you how to paint a horse using ink only. In order to achieve the three-dimensional look of the muscles, use different brushstrokes and different tones of ink.

STEP 1

Dip the Red Bean brush into diluted ink (see page 31). Holding the brush in an upright position, use the tip to sketch the horse, using wrist movements for short lines and elbow movements for longer lines. Mark the positions of the muscles. This is important, because the application of ink will depend on the position of the muscles. You do not need too many, or you will lose the effect, but you must have sufficient ink to show the tight body structure. I like to draw the face and the legs with dark ink at this early stage, using the Red Bean brush. I do this to show off the strength of the legs and elegant features of the face.

STEP 2

Load the small Mountain and Horse brush with dark ink to paint the muscles, joints, and other areas that are in shadow. Use a straight side brushstroke for the neck, curved side brushstroke for the body, and press-and-lift side brushstrokes for the joints of the legs. Before the dark ink dries, go straight to step 3.

STEP 3

Clean the small Mountain and Horse brush and load it with medium ink (see page 31). Add more brushwork to the body. The medium ink will run into the dark ink and create tones. Do not cover the whole body with ink; remember to leave some blank spaces to create the light effects.

STEP 4

Dry the small Mountain and Horse brush and load it with dark ink. Place the brush at a low angle along the side of the neck. Make a few side brushstrokes, using the press-and-lift technique, to create the mane. Press and lift away from the neck. Dry the brush and dip it into dark ink again. Place the tip of the brush at the hindquarters of the horse, where the tail begins. This time, hold the brush at a high angle to the paper, with the handle pointing to the direction in which the tail is flowing. Paint the tail with two or three brushstrokes, using the press-and-lift technique. Note that I changed the direction of the tail in order to convey that it is swinging.

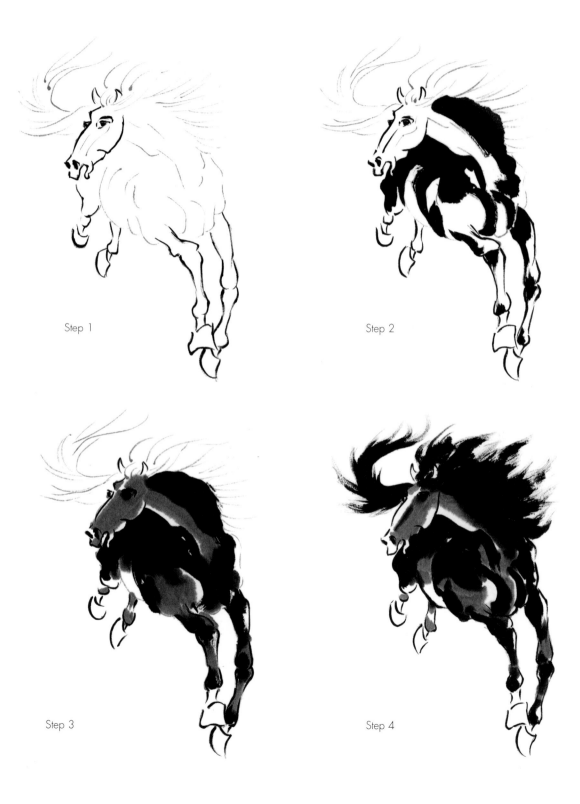

Step 1

Step 2

Step 3

Step 4

PAINTING HORSES USING WATERCOLOR AND INK

This painting of a mare and her foal is mainly worked using method 2 (pages 108–109), though I also use method 1 (page 107). Refer to the section on combining methods as well (page 111).

COLORS
• Ink
• Burnt sienna
• Sap green

BRUSHES
• Red Bean brush
• Size 3 Leopard and Wolf brush
• Small Orchid and Bamboo brush
• Small Mountain and Horse brush

STEP 1

Draw the outline of the mare and foal, using diluted ink (see page 31) and the Red Bean brush. Next, prepare burnt sienna and diluted burnt sienna. At the same time, prepare darker burnt sienna by adding a tiny bit of ink to burnt sienna. Begin with the mare. Use the size 3 Leopard and Wolf brush and clean water to wet the parts that you want to leave pale, such as the lower part of the neck and the top of the hindquarters. Fully load the small Orchid and Bamboo brush with diluted burnt sienna and paint in the relevant parts. Leave gaps between folds and brushstroke areas so that later, when you apply the undiluted burnt sienna in the gaps, the darker color will create shadows along the folds. Repeat the process with the foal, this time using darkened burnt sienna.

STEP 2

While the diluted colors on the mare are still wet, fully load the small Mountain and Horse brush with undiluted burnt sienna and finish applying colors to the mare. Next, dip the brush into darkened burnt sienna and use it to further enhance the shadows. Leave all the brushwork to dry.

STEP 3

Dip a dry Red Bean brush into dark ink (see page 31), then use broken lines to outline the horses. Next, load a dry small Mountain and Horse brush with dark ink. Holding the brush at a high angle to the paper, use the press-and-lift technique to paint the tails and the mare's mane, and then use side brushstrokes, again made with the press-and-lift technique, to paint the foal's mane. Dip a dry small Mountain and Horse brush into a mixture of sap green and burnt sienna. Press it on the mixing dish until the hairs separate and then paint in the grass with long dots.

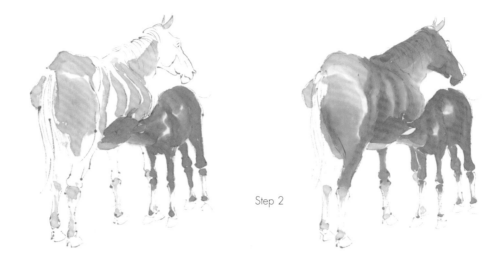

Step 1

Step 2

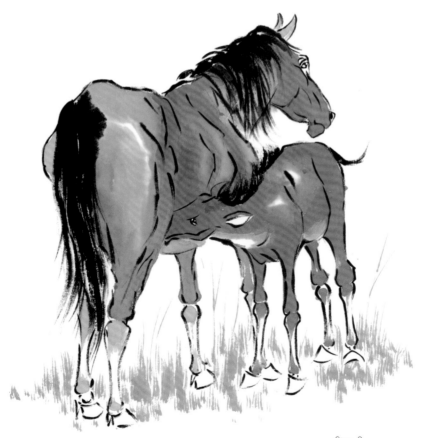

Step 3

MORE ANIMALS PAINTED USING TONAL TECHNIQUES

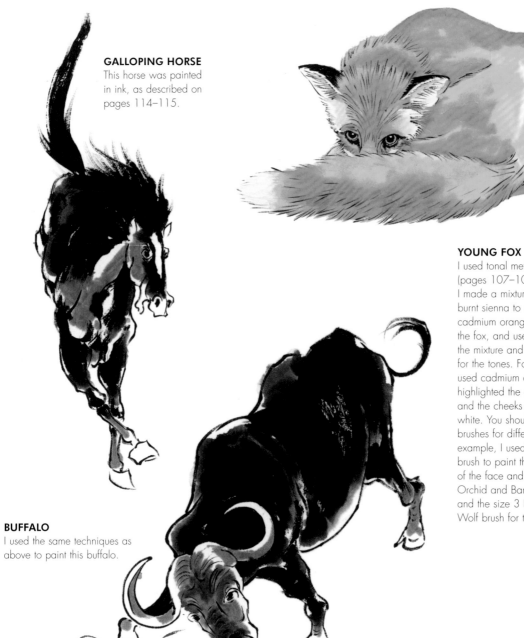

GALLOPING HORSE
This horse was painted in ink, as described on pages 114–115.

YOUNG FOX
I used tonal methods 1 and 2 (pages 107–108) for this fox. I made a mixture of one part burnt sienna to one part cadmium orange for coloring the fox, and used two tones of the mixture and clean water for the tones. For the eyes, I used cadmium orange. I also highlighted the end of the tail and the cheeks with Chinese white. You should use different brushes for different areas. For example, I used the Red Bean brush to paint the small details of the face and the small Orchid and Bamboo brush and the size 3 Leopard and Wolf brush for the body.

BUFFALO
I used the same techniques as above to paint this buffalo.

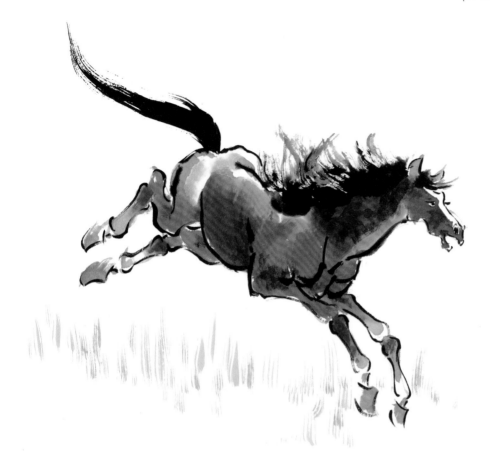

PRANCING HORSE

I used four tones to paint this horse. The darkest tones are provided by dark ink and diluted ink (see page 31). I also mixed a little alizarin crimson into burnt sienna to make the reddish brown for the coat and diluted some of this mix for the lighter areas. In some areas I allowed the ink and color to run into each other, creating a fifth tone.

LIONESS

This painting of a lioness drinking at a water hole shows how you can create a range of colors and tones from just two or three colors of your choice. Here, I chose cadmium orange, burnt sienna, and ink, and went on to mix or dilute them to expand the range. For her body I used burnt sienna, a mixture of two parts cadmium orange and one part burnt sienna, and burnt sienna darkened with a little ink. I also diluted the cadmium mixture to provide a fourth tone. For the lightest areas I used method 1 (page 107), using clear water to create yet another tone.

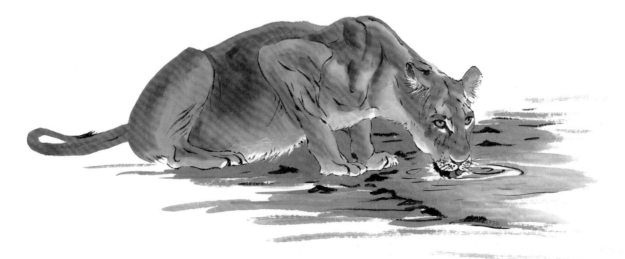

PAINTING ELEPHANTS

COLORS
• Ink
• Burnt sienna
• Darkened burnt
 sienna, made by
 adding a tiny bit of
 ink to burnt sienna

BRUSHES
• Small Mountain and
 Horse brush
• Large Bear-hair
 brush or extra-large
 Mountain and Horse
 brush

African elephants are the largest land animals on earth, and there are many ways of painting them, most of which concentrate on the many folds of the body. Here I have used the two-color loading technique to express these folds. A good big brush, such as the large Bear-hair brush or the extra-large Mountain and Horse brush, is useful for this purpose. Since I have used the large Bear-hair brush on a few occasions, I decided to use the extra-large Mountain and Horse brush to paint all the following illustrations. It's worth noting that elephants are also frequently painted with two tones of ink.

The features of an elephant are comparatively more complex than those of other animals, so painting them is never easy. I will start by showing you how to approach each part of the body. Finally, I will put everything together.

Painting the parts of an elephant

An elephant's body has many folds. To make the shaded parts of the folds darker, I use the two-tone or two-color technique. Always make sure that the nib of the brush, bearing the darker tone or color, is placed in the parts that are intended to be darker.

EARS

I start with the ears, because they are the most distinctive part of an elephant and reflect its character. Fully load the extra-large Mountain and Horse brush with the darkened burnt sienna and dip the nib into ink. The ears of the elephant are naturally darker at the outer edges. Place the nib of the brush at the edge of the ear, holding the brush at a low angle to the paper. Paint a reverse fan brushstroke. Reload the brush with fresh colors and add another reverse fan brushstroke, next to the first one. Add successive brushstrokes until the whole ear is filled with colors. If your brush tip is not long enough to cover the whole ear, paint as near to the edge as you can first and then fill the rest of the ear with the darkened burnt sienna.

First reverse fan brushstroke.

An elephant's ear.

TRUNK

The tip of the trunk is usually darker. Fully load the extra-large Mountain and Horse brush with darkened burnt sienna and dip the nib into dark ink (see page 31). Holding the brush in a vertical position, place the nib of the brush at the tip of the trunk and shape it. Next, press the brush tip and continue to paint a long brushstroke along the trunk, pressing the brush to cover as much as possible of the area of the trunk. Clean the brush and reload with the darkened burnt sienna to touch up the rest of the trunk.

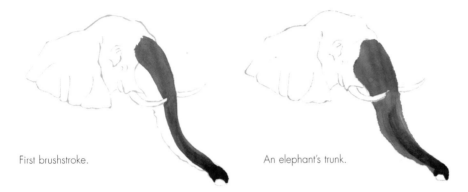

First brushstroke.

An elephant's trunk.

HEAD

Once you have finished painting the ears and the trunk, you can fill in the rest of the head. Watch out for the areas that are in the shade. Fully load the extra-large Mountain and Horse brush with the darkened burnt sienna and dip the nib into dark ink. Choose one part, such as the cheek below the eyes and behind the ear. Place the nib of the brush in the shadowed area under the ears and use a reverse fan brushstroke to cover the area. Use a similar technique to paint the rest of the head.

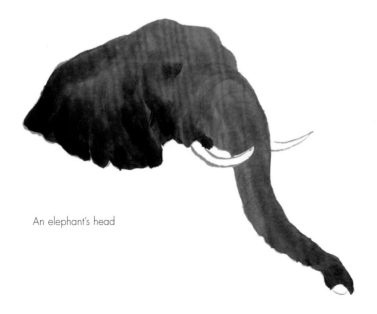

An elephant's head

LEGS

Fully load the extra-large Mountain and Horse brush with the darkened burnt sienna and dip the nib into dark ink (see page 31). Hold the brush in a vertical position. Use the nib of the brush to carefully paint around the toes. Press the brush and continue to move upward along the leg, covering as much of the leg area as possible. Clean the brush and reload it with the darkened burnt sienna to touch up the remaining area of the leg.

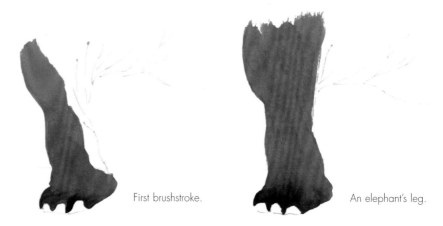

First brushstroke.

An elephant's leg.

BODY

An elephant's body has many folds of skin. We will use a two-color loaded brush to paint these. Fully load the extra-large Mountain and Horse brush with the darkened burnt sienna and dip the nib into dark ink. Hold the brush at an angle and place the nib of the brush at one end of a fold. Carefully move the brush along the fold with an extended long dot. Press the brush to fill the area of the fold. Reload the brush in the same manner and paint another fold. Continue to add more folds of skin in this way. For wider folds, you may have to hold the brush at a lower angle and use side brushstrokes.

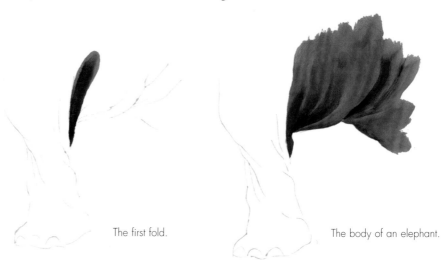

The first fold.

The body of an elephant.

ROUGH SKIN

The skin of an elephant is very rough. We use a dry brush loaded with ink to paint this rough skin. Dip the small Mountain and Horse brush into medium ink (see page 31). Wipe the brush on a piece of paper towel to remove excess moisture until it is dry. Hold the brush at a low angle on any part of the body where you want to show rough skin, and rub the brush on the paper.

Rough skin.

TAIL

The tail is insignificant in shape and size compared to the body, but if you are going to paint the back of an elephant you need to show the tail. Load the brush with darkened burnt sienna and dip the nib of the brush into ink before painting the folds at the hindquarters, using the techniques already described. Next, color the tail with darkened burnt sienna and add the hair at the end of the tail with dark ink (see page 31).

Tail.

PAINTING AN ELEPHANT

Now we put everything together and paint the elephant from start to finish.

STEP 1

Use the Red Bean brush to outline the elephant with diluted ink (see page 31).

STEP 2

The elephant is a huge animal, and when you apply such a large area with color, the build-up of moisture in absorbent paper will cause the color to run beyond the outlines you have sketched. For this reason, I start with colors. When all the colors have dried, I add outlines with dark ink (see page 31). This way, you can correct any overrun of colors beyond the original outline. I always like to start with the foreparts and work my way backward. Begin to paint the parts of the elephant, referring to the instructions on pages 120–123.

A tip about coloring: If you make the color thicker and wipe the brush against the palette after loading to squeeze out excessive moisture, this will minimize the chances of the color running out of control.

STEP 3

Complete the coloring of the whole body. Refer to the steps on pages 120–123.

STEP 4

Use a dry Red Bean brush and dark ink (see page 31) to draw lines wherever necessary. I added the outlines because I wanted to show you what they are like. You may choose to have a minimal number of outlines or none at all for your final artwork. The final step is to rub medium ink on the body with a dry small Mountain and Horse brush to make the skin rough. Use Chinese white to color the tusk. Dilute the dark ink and color the toes.

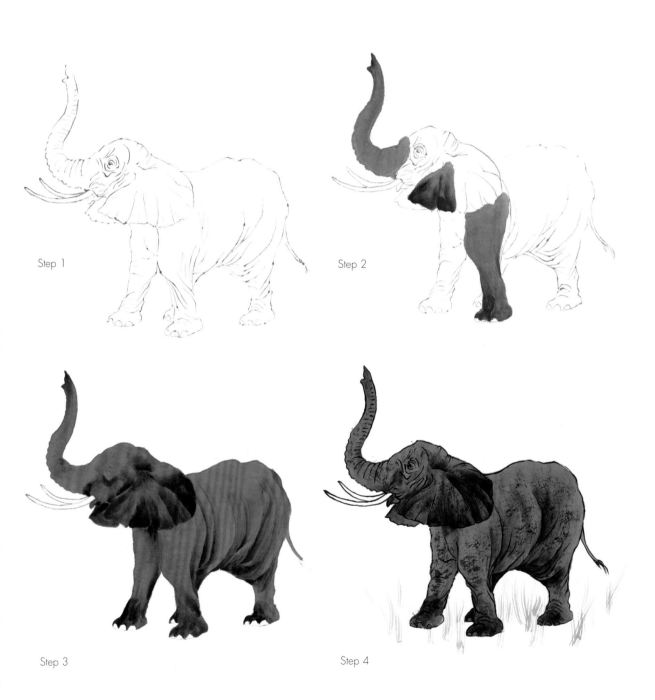

Step 1

Step 2

Step 3

Step 4

PROJECT: RUNNING ELEPHANTS

Any animal can be painted in more than one way. I have used a different approach to paint these elephants because I wanted to show you how you can be flexible when choosing methods to paint an animal.

COLORS
- Ink
- Burnt sienna
- Chinese white
- Indigo
- Cobalt blue

BRUSHES
- Red Bean brush
- Size 3 Leopard and Wolf brush
- Small Orchid and Bamboo brush
- Small Mountain and Horse brush
- Extra-large Mountain and Horse brush
- Hake brush

STEP 1

Draw the outlines of the two elephants with the Red Bean brush and diluted ink (see page 31).

STEP 2

Prepare burnt sienna darkened with a little bit of ink. Use toning methods 1 and 2 (see pages 107–108) to apply colors to the elephants, first with clean water, then burnt sienna, then burnt sienna darkened with a little ink, then diluted ink, finishing by applying dark ink. Use different sizes of brush for different parts of the body: size 3 Leopard and Wolf brush and the small Orchid and Bamboo brush for smaller areas, and the small Mountain and Horse brush and extra-large Mountain and Horse brush for the larger areas. Do not paint the feet completely: leave some parts unfinished to create the effect of dust raised by the running elephants. Leave all colors to dry.

STEP 3

When all brushwork areas are dry, use the Red Bean brush and dark ink to add outlines, eyes, toes, folds on the ears, trunks, and bodies. Dip the small Mountain and Horse brush into medium ink. Wipe the brush on a paper towel to remove excess moisture. Rub the brush on the body of the mother elephant to make it look rough. Load the small Mountain and Horse brush with dark ink and add brushwork to the ground, using a mixture of lines with the press-and-lift technique and side brushstrokes.

STEP 4

Prepare indigo, diluted indigo, cobalt blue, diluted cobalt blue, burnt sienna, and diluted burnt sienna. Wet the area you want to leave blank with clean water, using the small Orchid and Bamboo brush. Next, use a mixture of the colors you prepared to apply washes to the sky and the ground (see page 172). You can use the small Mountain and Horse brush, the extra-large Mountain and Horse brush, the Hake brush, or all three.

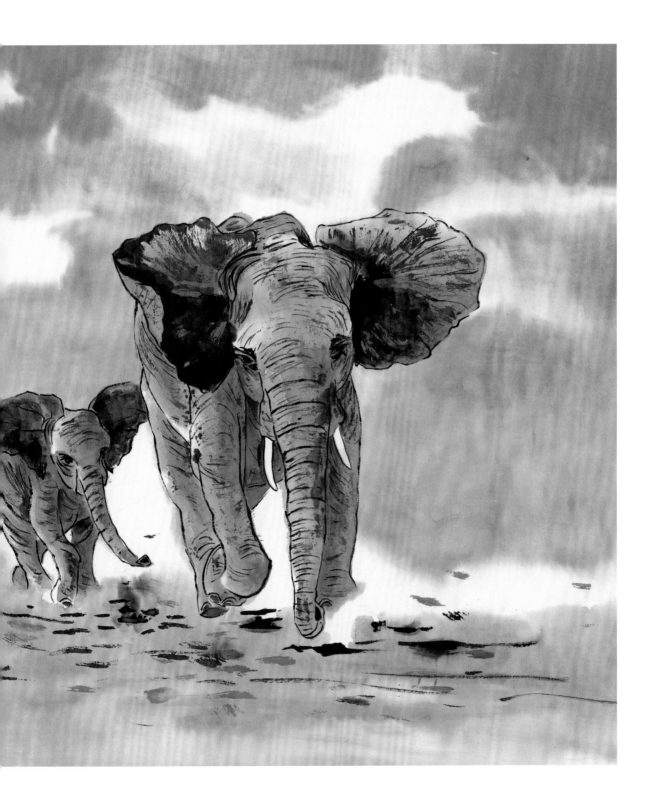

USING BROKEN BRUSHSTROKES

If you press the brush tip until the hairs separate, before or after loading it with color, and then make a brushstroke, the resulting mark will have blank gaps. We call this a broken brushstroke. In animal painting, broken brushstrokes are popularly used for creating hair or fur. In this section we will explore the range of broken brushstrokes that can be created using Chinese brushes.

Different animals have different types of hair. For example, squirrel tails are fluffy, but the hairs on their bodies are closely packed. Badger hairs are coarse and create wavelike shadings on the body. Hedgehog bristles are very coarse and have white tips. These varying effects can be achieved by using a wide range of brushes and loading them with differing amounts of color. Three different brushes have been used in this section to create broken brushstrokes: a small Landscape brush, a large Landscape brush and a small Mountain and Horse brush. Broken brushstrokes created by each of these brushes vary in size and texture. In order for the broken brushstrokes to be effective, the following three practices are essential.

BEFORE MAKING BROKEN BRUSHSTROKES

1. Make sure the brush is dry before loading it with color. This way you can control the amount of moisture you load onto your brush. If your brush is wet, this will cause the colors to run and destroy the effect of broken brushstrokes, so wipe it thoroughly dry with a paper towel before loading it with color.

2. Make the color thick for broken brushstrokes. Too watery a color will result in the color running on the absorbent paper, destroying the effect of broken brushstrokes. I mix one part of color from the tube with, at most, two parts of water. You can experiment with different amounts of water to discover the mix you are happy with. If you are preparing ink by grinding the ink stick, make the ink thick. If you are using liquid ink, leave the ink in the open for about ten minutes so that it thickens up before use.

3. After the brush is loaded with color, press the end on the palette to separate the hairs. Do not press it on the absorbent paper, because the paper will absorb the moisture, destroying the delicate balance and ruining the final effect. After one or two brushstrokes, the hairs may come back together as it is the nature of brush hairs to return to a point. If this happens, press the brush tip again to separate the hairs.

Before showing you all the different brushstrokes, let's take a little time to understand the brushes we are using in this chapter: the small Landscape brush, the large Landscape brush, and the small Mountain and Horse brush. Wolf hairs are softer and finer than horsehair, so wolf-hair brushes make broken brushstrokes with finer lines, creating a

softer effect, while horsehair brushes make brushstrokes with thicker and harder lines. The width of a broken brushstroke will depend on the size of the brush tip. The small Landscape brush has the smallest brush tip of the three, so a broken brushstroke produced by this brush is narrow, while one made by the small Mountain and Horse brush will be wider. The length of a brushstroke will also depend on the size of the brush tip. For example, the small Landscape brush can only hold sufficient moisture to sustain a short brushstroke, while the small Mountain and Horse brush is able to make a longer brushstroke. So if you are not using the three brushes specified here and want to choose your own brushes for painting broken brushstrokes, keep these characteristics in mind when you are buying your brushes.

You can create many types of broken brushstroke with these three brushes. I am going to show you four types here.

Technique 1
Broken brushstrokes with separated lines.

Technique 3
Coarse broken brushstrokes.

Technique 2
Denser broken brushstrokes with lines.

Technique 4
Closely packed broken brushstrokes.

In this section, if the bodies of the animals are colored using the methods for applying tones described on pages 106–111, I have normally used the technique for applying colors separately. A reminder: I start with clean water at one edge and then apply the lighter color up to the edge of the clean water, finishing with the darker color next to the light color.

TECHNIQUE 1: BROKEN BRUSHSTROKES WITH SEPARATED LINES

Dip a dry brush tip halfway into ink. Press the brush on the palette until the hairs separate. Holding the brush in a vertical position, paint a long brushstroke. The resulting brushstroke has uniform thin separated lines.

Broken brushstrokes made with the small Landscape brush are narrow, short, and soft. Those made by the large Landscape brush are wider, longer, and soft. The strokes made by the small Mountain and Horse brush are wide, long, and hard.

Use different brushes to create different areas of hair. For example, the hairs of the face and head of an animal are shorter and finer, so the small Landscape brush is more suitable for this purpose. Many animals have soft, short hairs on their bodies. A large Landscape brush will be good for this. The male lion has long hairs in his mane, for which the small Mountain and Horse brush is a perfect tool.

Broken brushstrokes made by a small
Landscape brush are narrow, short,
and soft.

Straight brushstroke.

Curved brushstroke.

Press-and-lift brushstroke.

Broken brushstrokes made by a
large Landscape brush are wider,
longer, and softer.

Straight brushstroke.

Curved brushstroke.

Press-and-lift brushstroke.

Broken brushstrokes made by a small
Mountain and Horse brush are wide,
long, and hard.

Straight brushstroke.

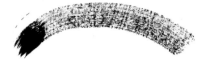

Curved brushstroke.

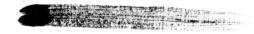

Press-and-lift brushstroke.

TECHNIQUE 2: DENSER BROKEN BRUSHSTROKES WITH LINES

If you repeatedly apply technique 1 to the same surface, the final brushwork will be dense, because the more brushstrokes you add, the denser the hair. You can make use of different degrees of density to control the shading of an animal's body: the denser the brushstrokes, the darker the hair.

USING A SMALL LANDSCAPE BRUSH

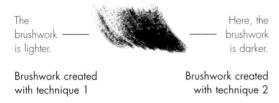

The brushwork ——— is lighter.

Here, the ——— brushwork is darker.

Brushwork created with technique 1

Brushwork created with technique 2

USING A LARGE LANDSCAPE BRUSH

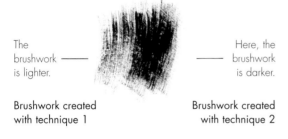

The brushwork ——— is lighter.

Here, the ——— brushwork is darker.

Brushwork created with technique 1

Brushwork created with technique 2

USING A SMALL MOUNTAIN AND HORSE BRUSH

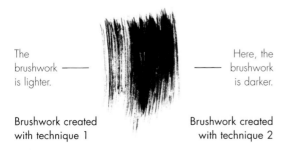

The brushwork ——— is lighter.

Here, the ——— brushwork is darker.

Brushwork created with technique 1

Brushwork created with technique 2

TECHNIQUE 3: COARSE BROKEN BRUSHSTROKES

Fully load a dry brush with ink or color and press the brush against the side of the palette to remove as much moisture as possible. The brush should be wetter than the one used in technique 1 (see page 129). After loading, press the brush tip on the palette until the hairs separate. Hold the brush in a vertical position and paint a broken brushstroke. The lines of the resulting brushstroke are thicker and closer together than those made with technique 1, so the hairs created with this technique are coarser.

Coarse broken brushstrokes, made with a small Landscape brush.

Coarse broken brushstrokes, made with a large Landscape brush.

Coarse broken brushstrokes, made with a small Mountain and Horse brush.

TECHNIQUE 4: CLOSELY PACKED BROKEN BRUSHSTROKES

Fully load a dry brush with thick ink or color. Press the brush on the palette until the hairs separate. Hold the brush in a vertical position and paint a brushstroke. The lines will be even thicker and only the starting point of the brushstroke will have the broken effect. The rest will be solid. This is especially useful for painting animals with closely packed hairs in the body and only a few loose hairs at the edges.

Broken brushstrokes, using technique 4 with a small Landscape brush.

Broken brushstrokes, using technique 4 with a large Landscape brush.

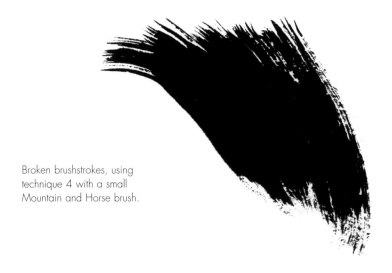

Broken brushstrokes, using technique 4 with a small Mountain and Horse brush.

COLORS
- Ink
- Burnt sienna
- Permanent rose
- Cadmium orange
- Gamboge
- Chinese white

BRUSHES
- Red Bean brush
- Outline brush
- Small Mountain and Horse brush
- Small Landscape brush
- Small Orchid and Bamboo brush
- Size 3 Leopard and Wolf brush
- Size 1 Wolf-hair brush for Painting

Lion

This painting uses technique 1 (see page 129). The lion's mane has layers of hair of different lengths. I began building up the framework with a dry brush and dark ink (see page 31). I then used colors to build up the different tones and at the same time make the mane thick.

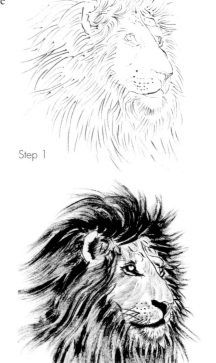

Step 1

Step 2

STEP 1
Use the Red Bean brush and diluted ink (see page 31) to sketch the head of a lion.

STEP 2
Use the Outline brush to draw the face of the lion with dark ink. You can use the cushion method to help steady the hand holding the brush (see page 45). Dip the brush tip of a dry small Mountain and Horse brush halfway into dark ink. Press the brush tip on the palette until the hairs separate. Paint with long brushstrokes to create the mane, following the pattern of your outline. Use a mixture of straight, curved, and press-and-lift broken brushstrokes. Use the same technique to add some texture to the face with the small Landscape brush. Leave all ink brushwork to dry before adding colors.

STEP 3
Prepare a mixture of one part burnt sienna and one part cadmium orange. Make the color thick, adding, at most, two equal parts of water to the colors. Use the same technique as in step 1 to color the mane with the small Mountain and Horse brush and then use medium ink (see page 31) to create shades in the mane with the small Orchid and Bamboo brush. Paint the face with diluted ink and burnt sienna, using the size 3 Leopard and Wolf brush and leaving out the hairs under the eyes and chin.

STEP 4
Use permanent rose to paint the nose. Color the eyes with burnt sienna around the pupils and the rest of the eyes with gamboge. You can use the Red Bean brush for coloring both the nose and the eyes. Add a few more whiskers with Chinese white, using the size 1 Wolf-hair brush for Painting. If your colors have run into the parts that are supposed to be left blank, such as the parts under the eye or under the chin, you can cover the overrun parts with Chinese white to restore them.

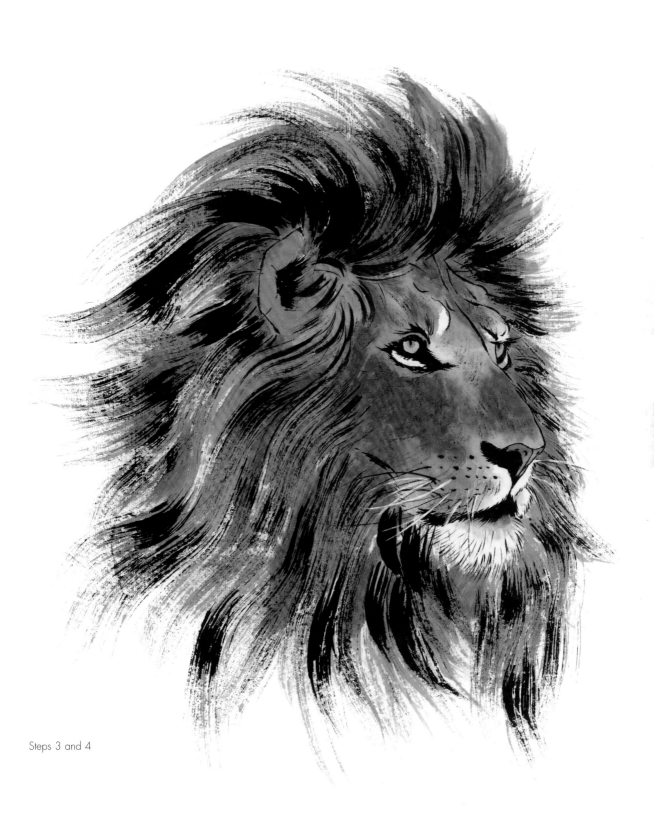

Steps 3 and 4

COLORS
- Ink
- Burnt sienna
- Permanent rose
- Sap green

BRUSHES
- Red Bean brush
- Outline brush
- Small Mountain and Horse brush
- Large Landscape brush
- Small Landscape brush
- Size 3 Leopard and Wolf brush
- Small Orchid and bamboo brush
- Size 1 Wolf-hair brush for Painting

Squirrel

To paint a squirrel, we combine technique 1 with technique 2 (see pages 129–131). To do this, we use all three brushes: the small Landscape brush, the large Landscape brush and the small Mountain and Horse brush.

STEP 1

Use the Red Bean brush and diluted ink (see page 31) to outline the squirrel.

STEP 2

We use dark ink (see page 31) to paint all the ink brushwork before applying the colors. Use the Outline brush to draw the details, such as the eyes, nose, ears, and feet. Use the small Mountain and Horse brush to paint the tail of the squirrel with broken brushstrokes, using technique 1. Next, use the large Landscape brush to apply broken brushstrokes to the body. Create shading by applying more brushstrokes to the darker areas. Finally, use the small Landscape brush to add shorter broken brushstrokes to the face. Leave all ink brushwork to dry.

STEP 3

Use the methods for applying tones described on pages 106–111 to apply colors. Prepare two colors: burnt sienna and burnt sienna darkened by adding a little bit of ink. Apply the colors with the size 3 Leopard and Wolf brush or the small Orchid and Bamboo brush, depending on the size of the squirrel. Actually, you can use both brushes: one loaded with burnt sienna and one loaded with darkened burnt sienna. Begin by applying clean water along the edge of the parts that are to be pale, then add burnt sienna to the edge of the clean water, followed by the darkened burnt sienna. Apply diluted permanent rose to the inside of the ears with the Red Bean brush. Using the size 1 Wolf-hair brush for Painting, dot the pupil of the eye with Chinese white. Use the Red Bean brush to color the acorn with sap green and diluted permanent rose. Paint grass in sap green and ink, using short broken brushstrokes.

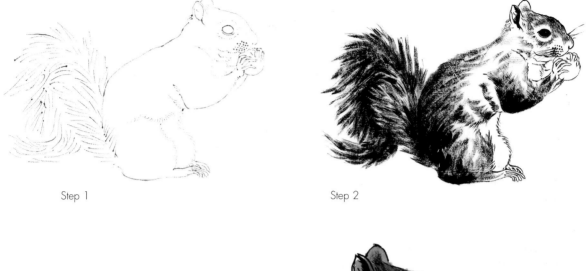

Step 1

Step 2

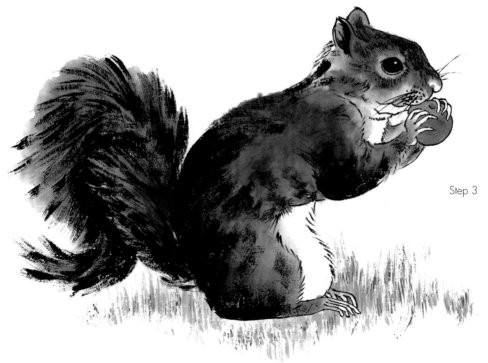

Step 3

COLORS
- Ink
- Burnt sienna
- Chinese white

BRUSHES
- Red Bean brush
- Outline brush
- Small Landscape brush
- Large Landscape brush
- Small Mountain and Horse brush
- Size 3 Leopard and Wolf brush
- Small Orchid and Bamboo brush
- Size 1 Wolf-hair brush for Painting

Badger

Badgers have coarse hair on their bodies, the hairs forming waves like shading. I use technique 3 (see page 132) for the body and technique 1 (page 129) for the softer tail.

STEP 1

Use the Red Bean brush to outline a badger with diluted ink (see page 31). A badger has definite white patches on its head and neck. Mark these parts so that they can be left blank when color is applied.

STEP 2

Use the Outline brush and dark ink (see page 31) to draw the face and the feet of the badger. Now add the ink tones. I used the small Landscape brush to paint broken brushstrokes with technique 3 for the head and the small Mountain and Horse brush for the body. For the tail, I used the large Landscape brush and technique 1. Leave the ink to dry.

STEP 3

Prepare burnt sienna and burnt sienna darkened with a tiny bit of ink. Use one or more of the techniques described on pages 106–111, for example method 2 on page 108, to color the body. Begin by applying clean water with the size 3 Leopard and Wolf brush to the parts that will be pale, such as the lower abdomen and part of the face. Next, use the small Orchid and Bamboo brush to apply burnt sienna up to the edge of the clean water. Finally, add the darkened burnt sienna. Dip the size 1 Wolf-hair brush for Painting into Chinese white and paint a tiny dot in the center of each eye to suggest reflected light.

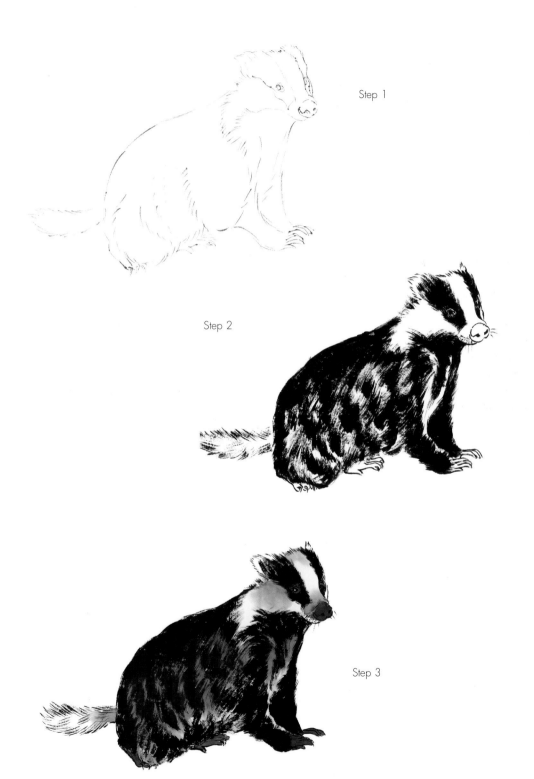

Step 1

Step 2

Step 3

COLORS
- Ink
- Burnt sienna
- Chinese white
- Indigo

BRUSHES
- Red Bean brush
- Outline brush
- Large Landscape brush
- Small Landscape brush
- Size 3 Leopard and Wolf brush
- Size 1 Wolf-hair brush for Painting
- Small Mountain and Horse brush

Otter

Otter fur is dense and tightly packed. To render their fur (which is wet all the time and therefore reflects the light,) we use technique 4 (closely packed broken brushstrokes, page 133). We can use Chinese white for this effect.

STEP 1

Use the Red Bean brush and diluted ink (see page 31) to sketch the outline of an otter. Use the Outline brush and dark ink (see page 31) to go over some of the features, as shown in the illustration opposite.

STEP 2

Prepare burnt sienna and burnt sienna darkened with a little bit of ink. Use the Red Bean brush to paint the tips of the toes with burnt sienna. Before the color dries, add the darkened burnt sienna and extend the coloring into the legs. Paint the body with the large Landscape brush and the face with the small Landscape brush, using technique 4 and the darkened burnt sienna. When you are painting the parts that have loose hair— for example, parts next to the abdomen, around the face and part of the tail—make sure that you place the tip of the brush, which has the separated hairs, on the outer edge. Add the darkened burnt sienna to the webs of the feet.

STEP 3

Dip the size 3 Leopard and Wolf brush into diluted burnt sienna. Color the face and neck. When you are painting the neck, apply clean water first and then diluted burnt sienna next to it, to create toning. Use the size 1 Wolf-hair brush for Painting to highlight the hair with Chinese white. Make sure you follow the contour of the body. Finally, paint a dot of Chinese white on each eye. Dip the small Mountain and Horse brush into diluted indigo and sweep a few lines to represent the water current under and behind the otter.

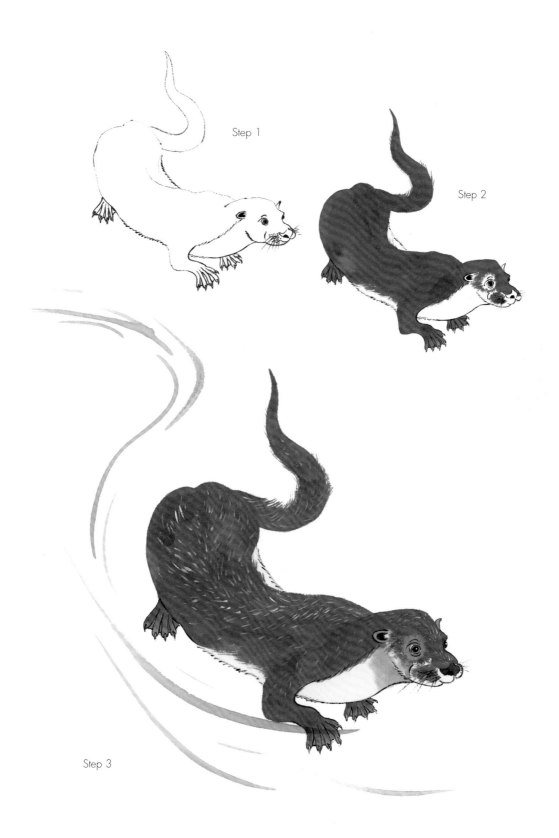

Step 1

Step 2

Step 3

MORE ANIMALS PAINTED WITH BROKEN BRUSHSTROKES

BORNEO ORANGUTAN

An orangutan has different lengths of hair in different parts of the body, those on the head being the longest. I used the small Mountain and Horse brush to start painting the hair with ink using technique 1 (see page 129). Next, I made a mixture of two parts burnt sienna and one part cadmium red deep and used this to add color to the hairs. I made another mixture with three parts burnt sienna to one part cadmium red deep. I diluted this and used it, together with diluted ink (see page 31), to color the body and the face. I used the small Orchid and Bamboo brush for coloring, wetting the lower edge of the shoulder with clean water before applying the color. This caused the color to run into the wet area and create further tones.

I colored the lips and nose with diluted permanent rose, using the Red Bean brush. The edges of the lips are left blank, because the Borneo orangutans have discolored edges to their lips, caused by the highly acidic content of their favorite food — rangas tree fruit.

PERSIAN CAT

Though the hairs of Persian cats are considered to be long, they are still short compared with those of lions and orangutans. As the hairs form short waves, I used the small Landscape brush to paint them, mostly with curved broken brushstrokes using technique 1 (see page 129). I used a little diluted burnt sienna and diluted ink (see page 31) to add shading to the hairs. I did not use much color because I wanted you to be able to see the ink brushwork making up the hairs. I used cadmium orange to color the eyes, with permanent rose for the nose. I shaded the outer edges of the eyes with diluted ink before applying the color.

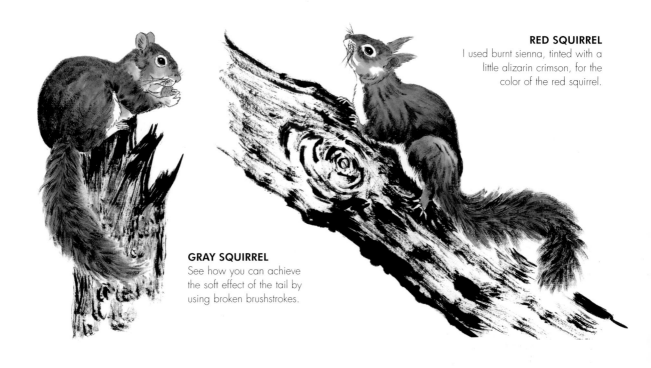

RED SQUIRREL
I used burnt sienna, tinted with a little alizarin crimson, for the color of the red squirrel.

GRAY SQUIRREL
See how you can achieve the soft effect of the tail by using broken brushstrokes.

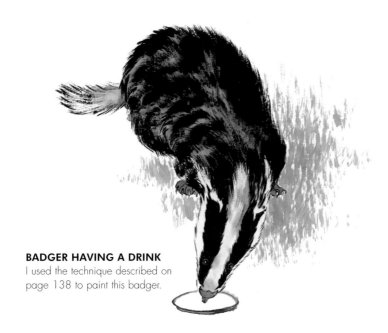

BADGER HAVING A DRINK
I used the technique described on page 138 to paint this badger.

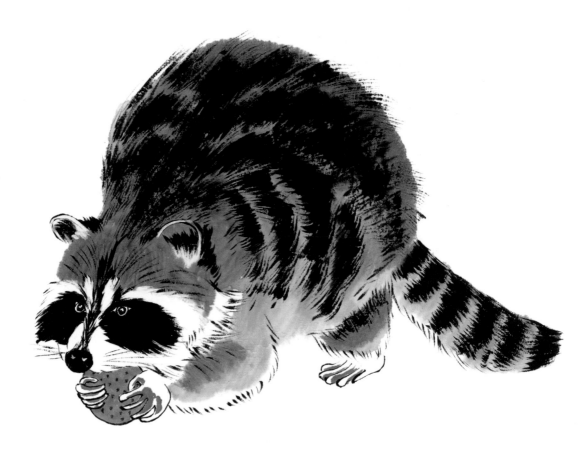

RACCOON

Raccoons have distinctive white and black facial patterns. The fur of a raccoon is coarse, similar to that of a badger. Painting a raccoon is also similar to painting a badger. Using technique 3 (page 132), I started the body with all the ink brushstrokes. When all the ink was dry, I used burnt sienna and darkened burnt sienna to add colors.

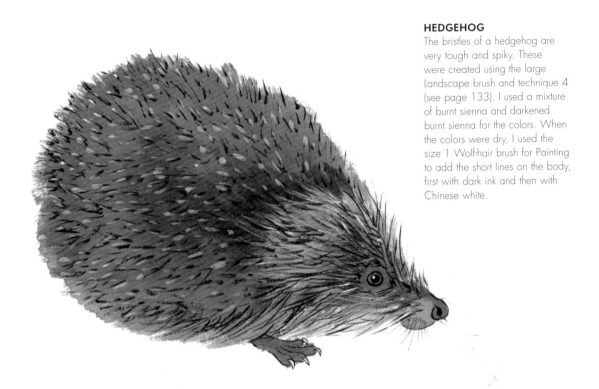

HEDGEHOG

The bristles of a hedgehog are very tough and spiky. These were created using the large Landscape brush and technique 4 (see page 133). I used a mixture of burnt sienna and darkened burnt sienna for the colors. When the colors were dry, I used the size 1 Wolf-hair brush for Painting to add the short lines on the body, first with dark ink and then with Chinese white.

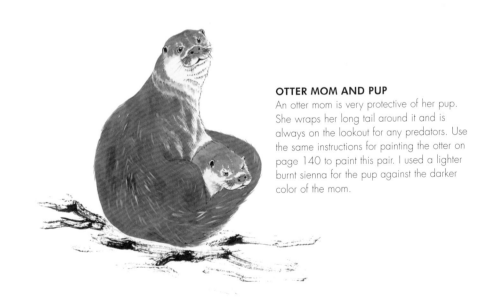

OTTER MOM AND PUP

An otter mom is very protective of her pup. She wraps her long tail around it and is always on the lookout for any predators. Use the same instructions for painting the otter on page 140 to paint this pair. I used a lighter burnt sienna for the pup against the darker color of the mom.

PROJECT: A POLAR BEAR

COLORS
- Ink
- Burnt sienna
- Chinese white
- Indigo and cobalt blue to color the paper before you start

BRUSHES
- Red Bean brush
- Size 3 Leopard and Wolf brush
- Small Landscape brush
- Large Landscape brush
- Outline brush
- Small Mountain and Horse brush

Painting animals with white hair requires extra work. First, you need a darker background to show off the white color of the animal, so start by applying a color wash to a piece of absorbent Xuan paper. Please refer to the Appendix for instructions of applying washes to absorbent Xuan paper (page 172). This can be a plain or multi-colored wash. In this project, I applied a plain wash to the paper, using a mixture of one part indigo to one part cobalt blue. Next, I added some patches of very diluted burnt sienna. Alternatively, you can use a piece of ready-tinted absorbent Xuan paper. This is usually available in the art shops where you get your Chinese painting materials. You do not necessarily have to choose a blue background.

STEP 1

Use the Red Bean brush to sketch the outline of the polar bear and the rocks on a colored absorbent Xuan paper. You can sketch with diluted ink (see page 31) or diluted Chinese white.

STEP 2

Add some shading with diluted burnt sienna and diluted ink to those parts of the body of the bear that are in shadow, such as between the legs and the divisions of the paws.

STEP 3

Dilute Chinese white by mixing one part Chinese white with one part water. Apply this Chinese white to the polar bear with the size 3 Leopard and Wolf brush. Leave the color to dry. This will form the background color of the body of the bear, making it easier for you to paint the broken brushstrokes. If you paint Chinese white on absorbent Xuan paper, the color usually causes the paper to stick to the underlining paper. If you lift the painting paper when this happens, you may tear it. To avoid this, lay your Xuan paper on a piece of paper towel when you are applying Chinese white, as paper towel has an uneven pattern, which prevents the Xuan paper sticking to it.

STEP 4

Paint the whitest part of the bear with Chinese white, using a combination of technique 1 and technique 2 (see pages 129–131). Use the small and large Landscape brushes.

STEP 5

Use the Outline brush to paint the small details on the face and the feet with dark ink (see page 31). Fully load the small Mountain and Horse brush with Chinese white. Paint multiple side brushstrokes with press and lift for the icy rocks.

POLAR BEAR

I used techniques 1 and 2 to paint this portrait of a polar bear, but you might like to experiment with the other ways of painting broken brushstrokes and compare the results.

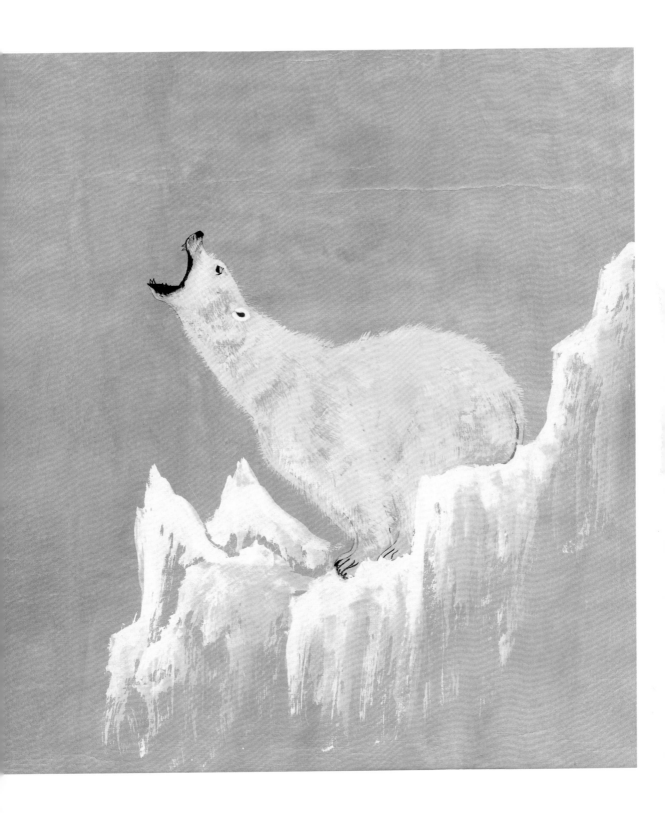

PAINTING ANIMALS WITH PATTERNS

Many animals have beautiful and striking patterns on their bodies. In order to make painting patterns more effective in non-outline painting, we have developed the dry method and the wet method, each of which has variations. The finished effects of each method are very different, so you can choose whichever suits your needs.

In this section, I have used a mixture of different techniques to apply the fur colors and patterns to the animals.

DRY METHODS

To paint an animal with patterns, you need to paint the patterns as well as applying the overall fur or skin colors to the body. In the dry method, you can start either with the patterns or with the colors, provided the first is dry before you start the other. Patterns created using dry methods are sharper and are perfect for painting predators, as the sharper patterns make them look more powerful and aggressive.

DRY METHOD 1

I drew the patterns with dark ink first. The size of brush used will depend on the size of the patterns. For an animal such as a tiger, I use the Red Bean brush for the face. For the body, you could use either the size 3 Leopard and Wolf brush or the small Landscape brush to paint the smaller brushwork, and the large Landscape brush or the small Mountain and Horse brush to paint the large brushwork. A mixture of cadmium orange and burnt sienna is added after the ink is dry.

DRY METHOD 2

I began with the base color first, and allowed the colors to dry before adding the patterns. Refer to dry method 1 for suggestions as to which brushes to use.

An example made with dry method 1.

An example made with dry method 2.

WET METHODS

When using wet methods, you also can start with either the base colors or the patterns. Whether you start with the base colors or the patterns, you must add the other while the first is still wet. This makes the patterns run, creating a soft and fluffy effect. This method is therefore more suitable for smaller, furry animals.

WET METHOD 1

If you start with the base colors, it is better for the applied colors to settle and dry *a little bit* before patterns are added. The patterns will still run as long as the surface is damp, but they will tend to run out of control if the surface is too wet.

In the illustration below, I began by applying burnt sienna to the paper. I let the color settle a little bit and then added the patterns with dark ink (see page 31). Refer to dry method 1 for suggestions as to which brushes to use.

WET METHOD 2

Start by painting the patterns. While the patterns are still wet, apply the colors on top. The colors also run, but the effect is not as soft as with wet method 1.

An example made with wet method 1.

An example made with wet method 2.

COLORS

- Ink
- Cadmium orange
- Burnt sienna
- Sap green
- Permanent rose

BRUSHES

- Red Bean brush
- Outline brush
- Size 3 Leopard and Wolf brush
- Small Orchid and Bamboo brush
- Small Mountain and Horse brush

PAINTING TIGERS

Tigers are famous for their beautiful, velvety fur with striking dark markings. Their faces are also very distinctive, with clear dark patterns. They may look tame and approachable when relaxed, but they are actually excellent, aggressive predators.

I used dry method 1 (page 148) to paint the patterns of a tiger. Though many artists favor the wet method for its fluffy effect, I prefer the sharper effect created by the dry methods.

STEP 1

Use the Red Bean brush and diluted ink (see page 31) to sketch the tiger. Take care when you draw the face, because the features are very unusual and show the tiger's character.

STEP 2

Use dark ink (see page 31) to draw the face. You can use either the Outline brush or the Red Bean brush. I used both: the Outline brush to draw some of the fine lines and the Red Bean brush for the rest of the brushwork. Vary the thickness of the lines by pressing and lifting the brush. Using the Red Bean brush, draw the outline of the body with dark ink. Next, dip the size 3 Leopard and Wolf brush into the dark ink and add the patterns on the body. Press the brush for the wider brushstrokes and lift it for thinner lines. For even wider lines, use the small Mountain and Horse brush. Let all the brushwork dry before the next step.

STEP 3

Prepare burnt sienna and a mixture of two parts cadmium orange to one part burnt sienna. Do not make the colors too watery: you need a thick color to create the thick, rich and velvety quality of the fur. I used three colors for toning: clean water, the prepared mixture, and burnt sienna. Using the size 3 Leopard and Wolf brush, apply clean water to the chest, lower abdomen, and part of the legs and feet. Refer to the illustration to see which parts are to be left blank. Fully load the small Orchid and Bamboo brush with the cadmium orange mixture and apply it to the body, overlapping the edges of the clean water a little. The color will start to run into the water.

STEP 4

Finally, use the small Mountain and Horse brush to apply burnt sienna to the body. This will create the toning effect formed by the three colors. Burnt sienna is also used to paint the face. Use the Red Bean brush to color the eyes with sap green and the nose and tongue with permanent rose.

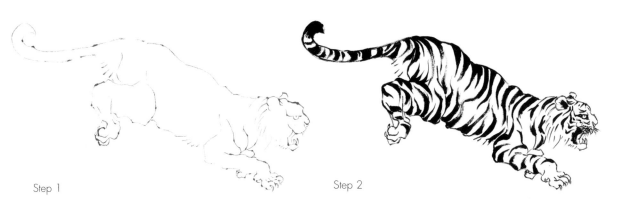

Step 1

Step 2

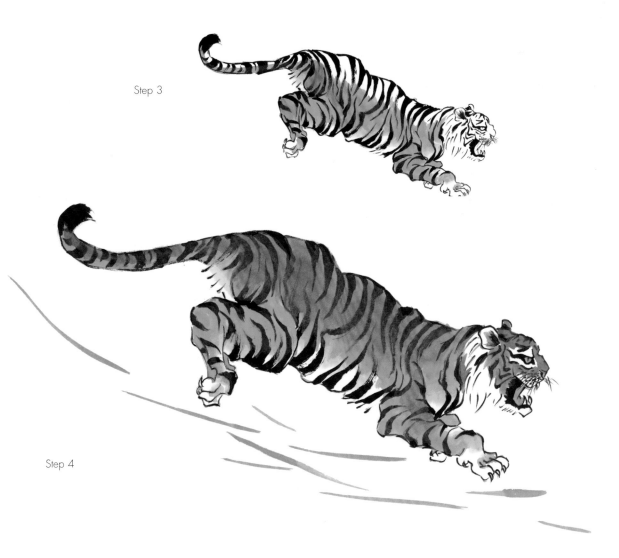

Step 3

Step 4

PAINTING LEOPARDS

Leopards display distinctive and beautiful patterns, which are usually made up of rosettes and dots. I used dry method 1 (see page 148) to paint the patterns. Dot the centers of the rosettes with burnt sienna before applying color to the body. The three colors creating the tones are clean water, a mixture of three parts gamboge to one part burnt sienna, and a mixture of equal amounts of gamboge and burnt sienna.

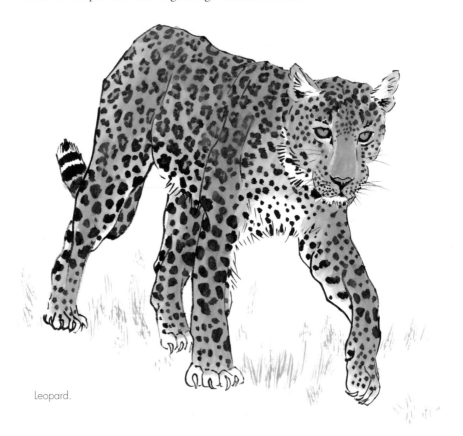

Leopard.

PAINTING JAGUARS

Leopards and jaguars are similar, but the latter are bigger and their bodies are sturdier. The markings on both animals are also similar, but the rosettes of leopards are smaller than those of the jaguar. Another difference is that there are dots in the centers of the rosettes of jaguars, but not in those of the leopards. To paint the jaguar opposite, I used the same techniques and colors that I used for the leopard. For the grass, I used a dry small Mountain and Horse brush to paint long dots of sap green.

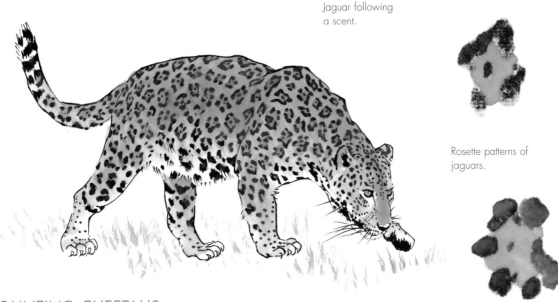

Jaguar following
a scent.

Rosette patterns of
jaguars.

PAINTING CHEETAHS

We can use the same techniques used to paint leopards and jaguars to paint cheetahs.
The bodies of cheetahs are marked with dots of different sizes. For the color of the body,
mix equal amounts of yellow ochre and burnt sienna. Dilute a small amount of this
mixture with water and then use clean water, the diluted mixture, and the undiluted
mixture to create the tones. Color the tongue with permanent rose.

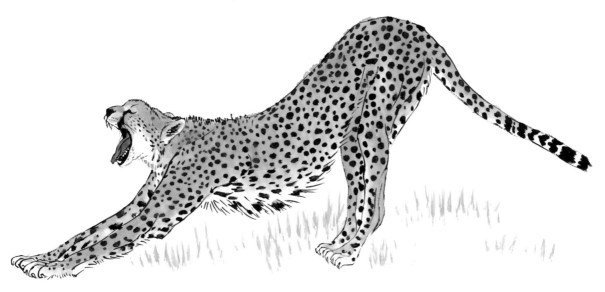

PAINTING GIRAFFES

Giraffes also have distinctive patterns on their bodies, usually consisting of patches that look like geometric figures. The colors of the patches vary: some are darker in color, while others are lighter; some have dark areas in the middle of the patches and others don't. Adults are darker in color than their young. In this illustration, I added a little bit of ink to burnt sienna to make the color darker. I used this darkened burnt sienna to paint the mother and burnt sienna for the calf. I wanted to show you their faces, so I did not include the whole of their bodies: they are simply too tall!

PAINTING ZEBRAS

I am always amazed by the striped pattern on the body of a zebra. The alternating dark and white lines extend to the mane and the tail and almost appear like a painted artwork. We can draw a zebra with dark ink and diluted ink (see page 31). Every line on the body is different and each one curves according to the contour of the body. Use the press-and-lift technique to achieve the different widths of the lines. As for brushes, use the Outline brush and the Red Bean brush to draw the lines on the face, and the small Landscape brush and the large Landscape brush for those on the body. Let all the ink dry. With the size 3 Leopard and Wolf brush, use diluted burnt sienna to create shaded areas and then use the diluted burnt sienna to retrace the diluted ink lines with the Red Bean brush.

The zebra is an artwork of lines.

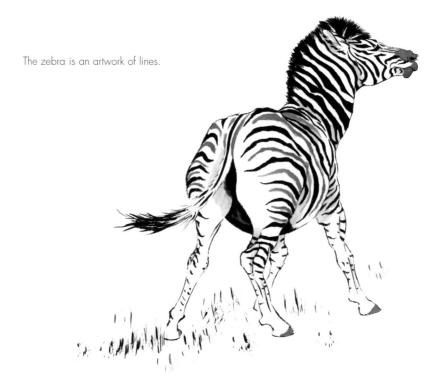

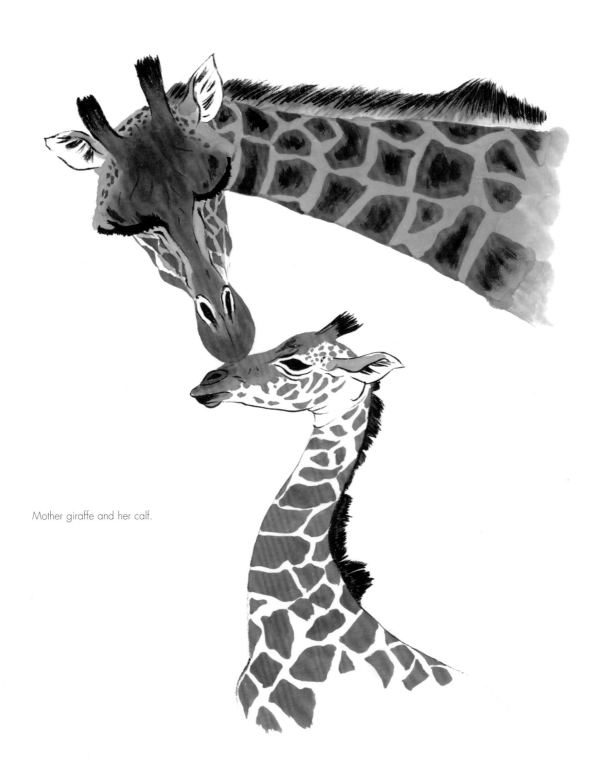

Mother giraffe and her calf.

PAINTING CATS

COLORS
• Ink
• Burnt sienna
• Alizarin crimson
• Sap green
• Permanent rose

BRUSHES
• Red Bean brush
• Outline brush
• Size 3 Leopard and
 Wolf brush
• Small Orchid and
 Bamboo brush

Cat fur patterns are soft, so the wet methods of applying patterns are ideal for this purpose (see page 149).

STEP 1
If you are using liquid ink, pour it out and leave it to thicken up. If you are using ink made by grinding an ink stick, thicken it with a bit more grinding. Start by using the Red Bean brush to make a sketch in diluted ink (see page 31).

STEP 2
Use the Outline brush and dark ink (see page 31) to draw the face, ears, paws, and lower abdomen.

STEP 3
Apply colors to the body. I mixed a little bit of alizarin crimson into burnt sienna. I then darkened a small amount of the color with a tiny bit of ink and used it for shading. Using clean water and the size 3 Leopard and Wolf brush, start by wetting the part you want to keep pale: the front, lower part of the legs, and part of the face. Apply the mixture, overlapping a little bit of the clean water patch with the small Orchid and Bamboo brush, and then add shading with the darkened mixture.

STEP 4
While the color is still wet, dip the size 3 Leopard and Wolf brush into the dark, thick ink and draw the pattern. Paint the nose with permanent rose and the eyes with sap green, using the Red Bean brush.

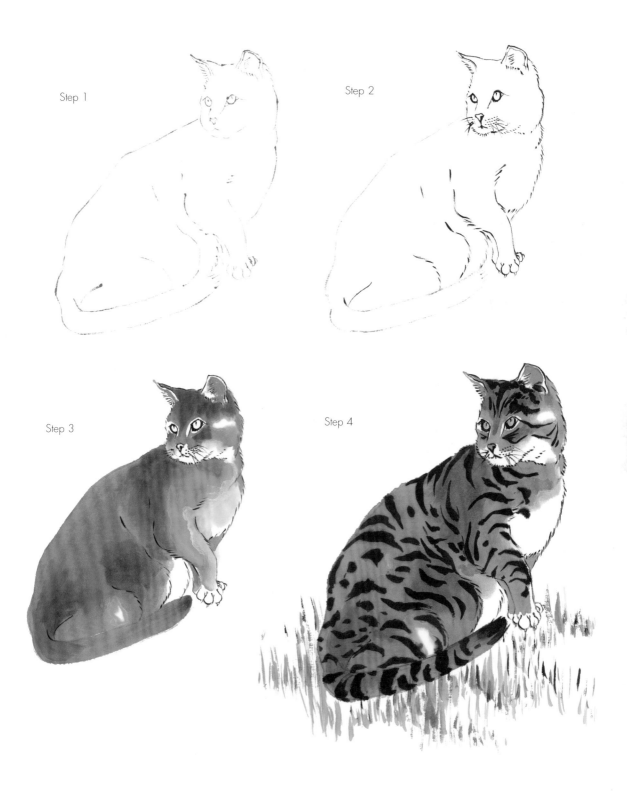

Step 1

Step 2

Step 3

Step 4

MORE CATS

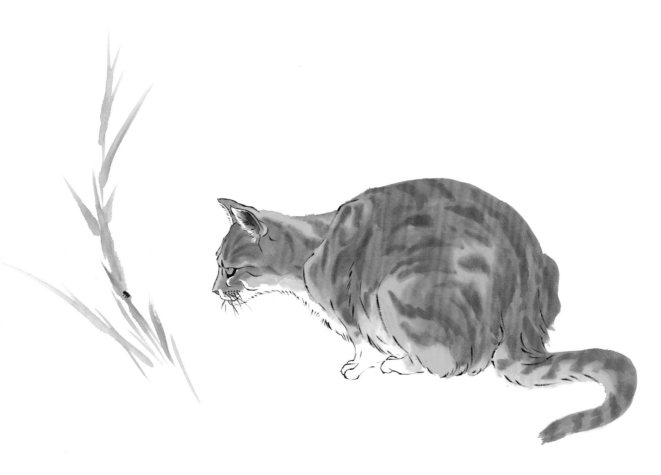

TABBY CAT
I mixed one part of burnt sienna with one part of cadmium orange. I then diluted some of this mixture to create a light tone. I used these two tones to paint the body of the cat. The pattern was applied with burnt sienna. I used permanent rose to paint the nose and a mixture of one part sap green to one part gamboge for the eye.

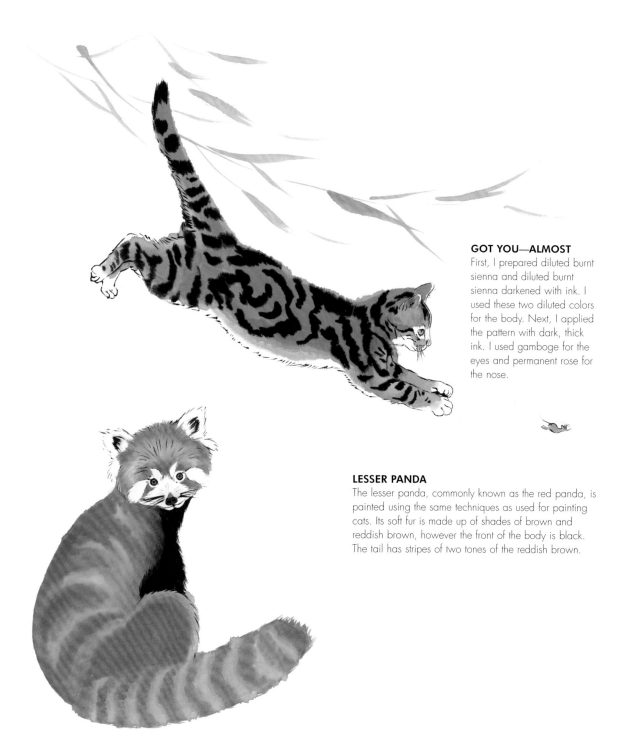

GOT YOU—ALMOST
First, I prepared diluted burnt sienna and diluted burnt sienna darkened with ink. I used these two diluted colors for the body. Next, I applied the pattern with dark, thick ink. I used gamboge for the eyes and permanent rose for the nose.

LESSER PANDA
The lesser panda, commonly known as the red panda, is painted using the same techniques as used for painting cats. Its soft fur is made up of shades of brown and reddish brown, however the front of the body is black. The tail has stripes of two tones of the reddish brown.

PROJECT: TWO TIGERS

COLORS

- Ink
- Cadmium orange
- Burnt sienna
- Sap green
- Indigo
- Cobalt blue
- Permanent rose

BRUSHES

- Red Bean brush
- Outline brush
- Small Landscape brush
- Size 3 Leopard and Wolf brush
- Small Orchid and Bamboo brush
- Small Mountain and Horse brush
- Hake brush, 2 in (5 cm) wide

STEP 1

Use the Red Bean brush and diluted ink (see page 31) to draw a sketch of the tigers and the pine trees.

STEP 2

Draw the faces of the tigers with dark ink (see page 31), using the Outline brush. Use the Red Bean brush and the small Landscape brush to add all the other features that should be in dark ink, such as the tail and the folds of the body.

STEP 3

Prepare a mixture of two parts of cadmium orange to one part burnt sienna. Use the size 3 Leopard and Wolf brush to wet the parts you want to leave blank—the lower abdomen, the feet and part of the faces—with clean water. Dry the brush before dipping it into the mixture and adding colors next to the clean-water areas, overlapping these a little. Next, use the small Orchid and Bamboo brush to apply burnt sienna to finish coloring. Paint the eyes with sap green, using the Red Bean brush. Paint the tongues and the noses with permanent rose, again using the Red Bean brush.

STEP 4

Make a dark green by adding a little bit of indigo to sap green. Draw the pine trees with dark ink, using the Red Bean brush. Use short lines to paint the pine needles. Dip the size 3 Leopard and Wolf brush into the dark-green mixture and add the colors to the trees.

STEP 5

Prepare a mixture of one part cobalt blue to one part indigo. Dilute part of this mixture. Dip the small Mountain and Horse brush into the diluted mixture. Wipe the brush on a piece of paper towel to make the brush dry. Hold the brush in a vertical position and sweep a few dry brushstrokes across the paper to create the mountain slopes.

STEP 6

Use the Hake brush and the two tones of blue to add washes around the pine trees (see page 172). Apply the diluted tone to the edges around the trees. Next, load the size 3 Leopard and Wolf brush with the undiluted tone and carefully fill up the background of the trees. When you color in the spaces between the pine leaves, leave blank spaces above the leaves to create the impression of a snow covering.

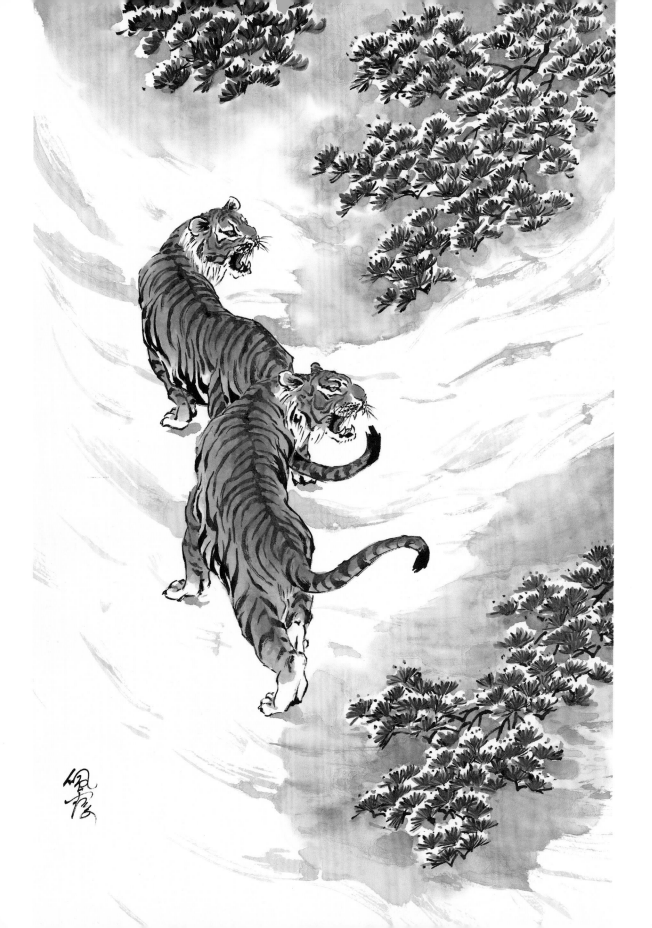

4 ANIMAL GALLERY

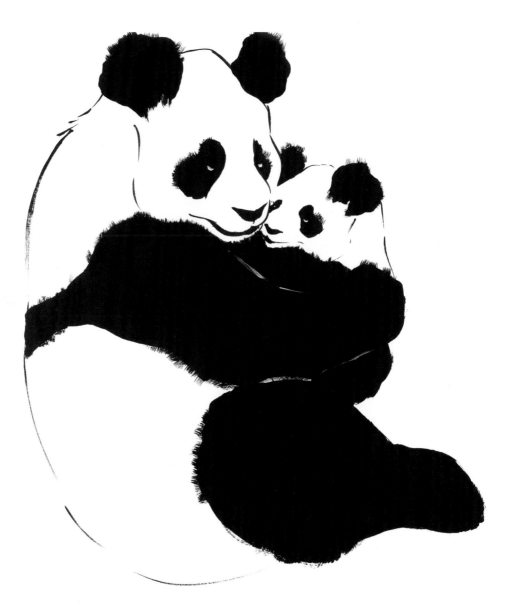

PANDAS—MOTHER AND CUB
This is just a matter of simple brushstrokes. The beauty of painting pandas is their simplicity.

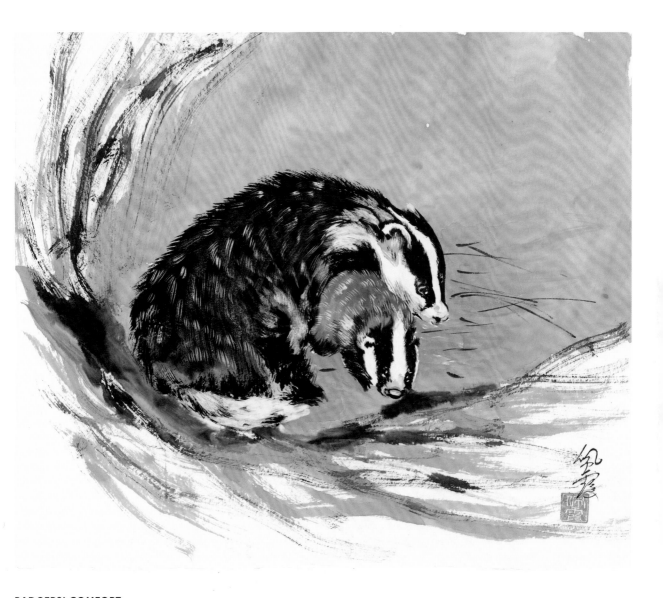

BADGERS' COMFORT

I used sweeping brushstrokes for this painting, more expressive than the ones I used to paint the badger on page 139, and created the fur with the help of Chinese white rather than leaving unpainted spaces.

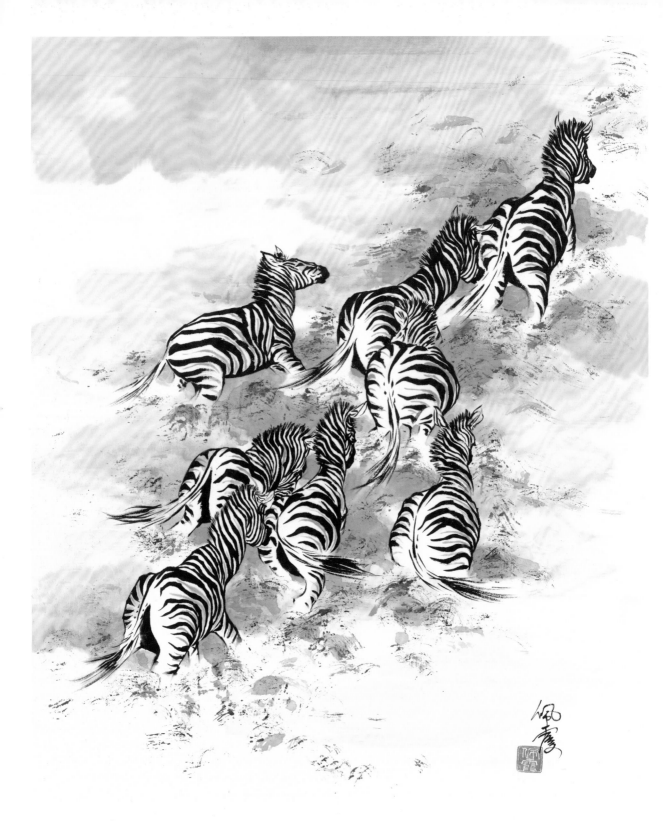

RUN, RUN

The techniques used for this composition are very simple: press-and-lift, dry brushwork and washes, with only ink and burnt sienna. The painting is brought to life by variations of the basic brushstrokes and a range of tonal techniques.

GOING AFTER PREY

A multi-color wash, the droplets of Chinese white, and the swinging tail emphasizes the tiger's action.

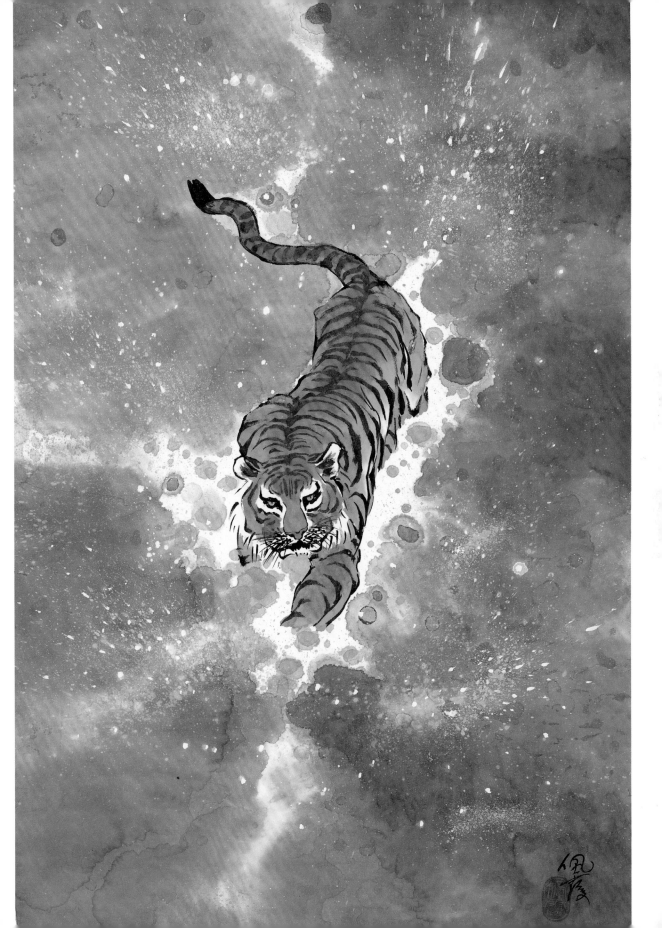

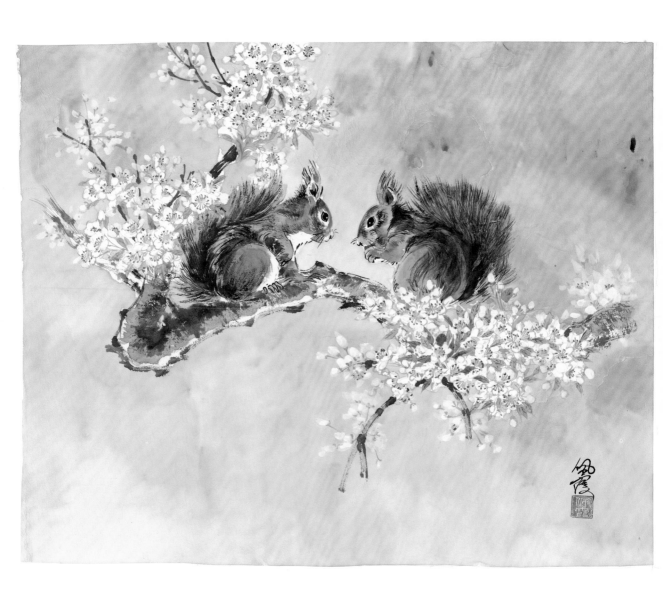

A SPRING ROMANCE BLOSSOMING

To create atmosphere in your work, it is helpful to put the
animals in a setting. Here the informal dotting of the blossoms
and the background give a sense of spring and romance.

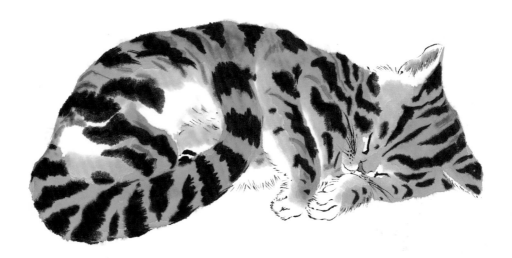

SWEET DREAMS
By now, you should be able to recognize the sweeping brushstrokes forming the tail, limbs, and back. Controlled sweeping brushstrokes won't look messy, even with two-tone or two-color loading.

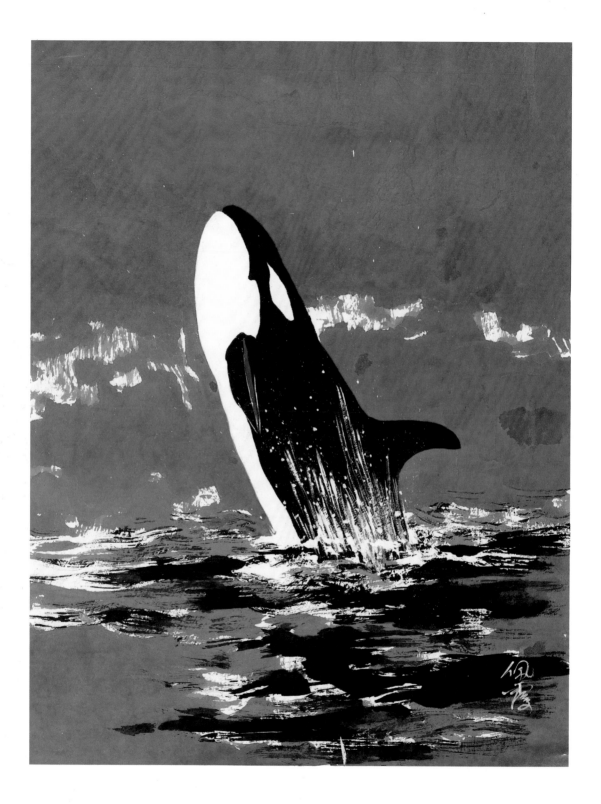

KILLER WHALE

A killer whale, with its simple patches of black and white, is a very striking and beautiful animal to paint. Adding the water with dry brushwork and washes makes the whale emerging from the water even more dramatic.

RAIN, RAIN, GO AWAY!

Gorillas do not seek shelter when it rains: they sit through it. Wet and dry techniques combine very well to create this painting. The rule is: don't hesitate; feel free!

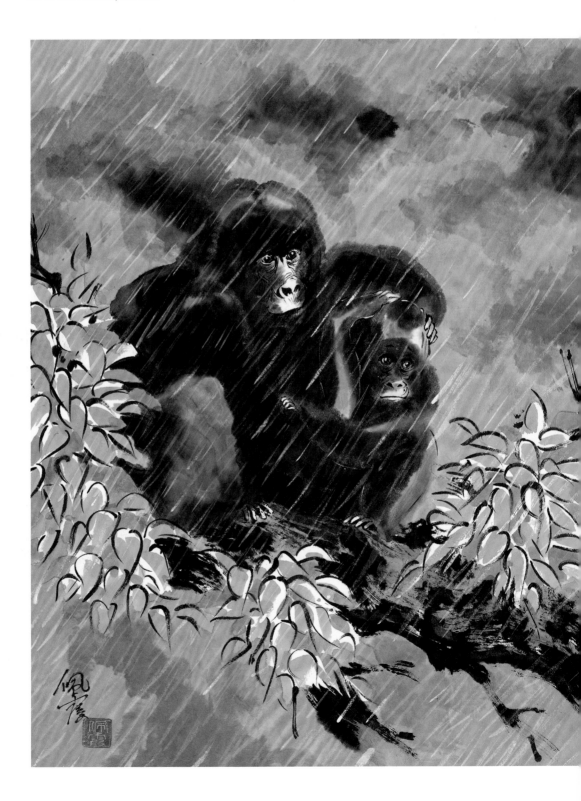

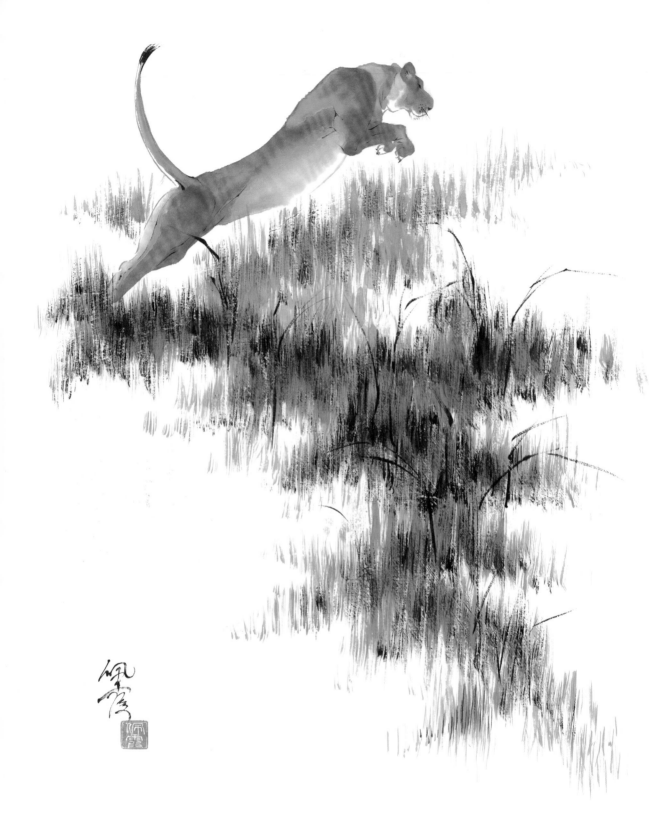

READY FOR THE KILL
The sweeping brushstroke is a very effective tool for painting animals in motion.

STAMPEDING HORSES

I love to sketch horses and use line and lots of color tones liberally. Once you have mastered these techniques, you will be able to draw lines, execute brushstrokes, and dot in color with great freedom. As my master once said, "The brush becomes an extension of your hand and your hand an extension of your heart." You can say freely what you want to say from your heart with a Chinese brush. Try it!

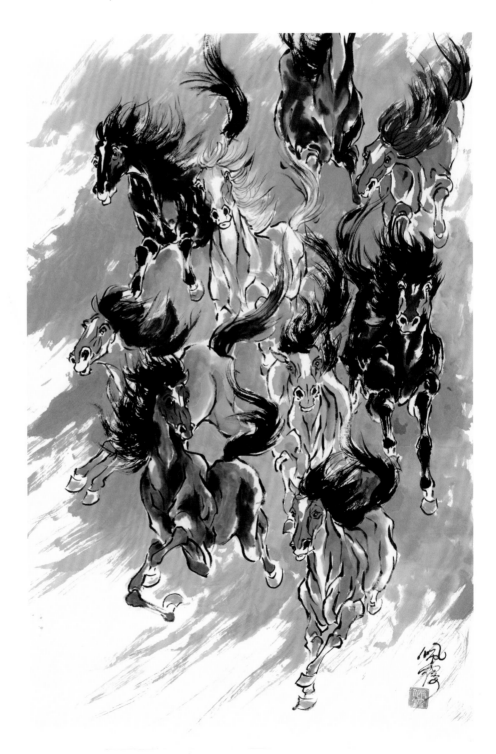

APPENDIX: WASHES

This section gives an overview of the different types of washes that are used to create the paintings in this book.

Tinting Xuan paper

If you want to tint a piece of absorbent Xuan paper, you will need a Hake brush at least 2 in (5 cm) wide. It is easier to apply a wash to Xuan paper with diluted colors, as thick color forms hard lines on absorbent paper. If you want the color to be darker, apply a first wash of diluted color and then, while the wash is still wet, add a wash of thicker color. The initial wash allows the second one to diffuse instead of forming hard lines.

Applying the first strip of color.

The most practical way to tint a piece of Xuan paper is to lay your paper on a flat surface, underlining it with a piece of clean newsprint. Fully load your Hake brush with the diluted color and start with your brush at the top of one corner. Touch your brush lightly on the paper and move across the top to form a strip. Do not press too hard on the paper or you will create creases. Reload your brush and add another strip, overlapping the first one a little bit. Always move your brush in the same direction—adding strips in the opposite direction will also create creases. Add successive strips until you have finished applying color to the entire piece of paper.

Place another piece of dry, clean newsprint on top of the wet Xuan paper. Turn over the whole pile—underlining paper, Xuan paper, and clean newsprint. The second clean sheet of newsprint is now under the Xuan paper. Peel off the original underlining paper and leave the Xuan paper to dry.

Tinting with multiple colors

If you want to tint a piece of absorbent Xuan paper with more than one color, start by wetting the paper with diluted tones of the various colors. While these are still wet, you can add stronger tones to build up the intensity of the colors.

Partial washes

You can apply colors to just one area of your paper, as I have done in many of my paintings. You can use a Hake brush, or a large brush such as the extra-large Mountain and Horse brush, the large Bear-hair brush, a Ti brush or a Dou brush to apply the wash with side brushstrokes.

If you want to give your partial wash softer edges, apply clean water along the edge of the area for the wash before applying color. This will help the color to diffuse.

Tinting with multiple colors.

Partial wash.

Partial wash with soft edges.

SUPPLIERS

EChinaArt Store
Tel: 1-718-938-6588
www.echinaart.com

China Art Material and Art Books
China Cultural Center
970 North Broadway
Suite 210
Los Angeles
CA 90012
USA
Tel: 1-213-626-7295
www.edu.ocac.gov.tw/home_en.htm

OAS (Oriental Art Supply)
21522 Surveyor Circle
Huntington Beach
CA 92646
USA
Tel: 1-714-969-4470
Tel: 1-800-969-4471
www.orientalartsupply.com

Oriental Culture Enterprises Co., Inc.
13–17 Elizabeth Street
2nd Floor
NY 10013
USA
Tel: 1-212-226-8461
www.oceweb.com/en/

Rochester Art Supply
150 West Main Street
Rochester
NY 14614
USA
Tel: 1-585-546-6509
www.fineartstore.com

INDEX

DISCARD

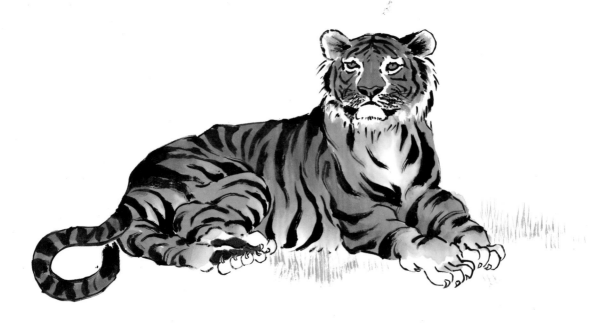